THEODORE ROOSEVELT &
BISON RESTORATION
—— ON THE ——
GREAT PLAINS

KEITH AUNE & GLENN PLUMB

WITH **CONTRIBUTIONS** BY **LEROY LITTLEBEAR,**
JIM POSEWITZ, KENT REDFORD, AMETHYST FIRST RIDER,
JIM DERR AND **DAVE HUNTER**

THE
History
PRESS

Published by The History Press
Charleston, SC
www.historypress.com

Cover images: Front, the Blackfeet Reservation with Glacier National Park in the background. *Courtesy of Tony Bynum.* Back, bison at Grand Teton National Park. *Courtesy of Jeff Burrell.*

First published 2019

Manufactured in the United States

ISBN 9781467135696

Library of Congress Control Number: 2018960985

Notice: The information in this book is true and complete to the best of our knowledge. It is offered without guarantee on the part of the authors or The History Press. The authors and The History Press disclaim all liability in connection with the use of this book.

CONTENTS

PREFACE

This book explores several important histories, not necessarily in chronological order, that otherwise risk being perceived as independent narratives. The reader is offered the opportunity to appreciate these multiple histories as they unfolded, sometimes pollinating the greater narrative and sometimes withering on the vine. Upon this reflection, there is an opportunity to look forward over the horizon, touching on great tragedy and potential redemption. The book is organized to convey these histories through thematic sections, including the *disappearance* of bison, their *arrival* back into the scene (recovery), the *awakening* of a conservation movement and the *convergence* of this history with modern times. Throughout, we intersperse short interludes about legacy bison and people who have helped shape these histories up through contemporary times.

The *disappearance* of bison from the land has been told and retold many times before. Herein, we reframe the story by highlighting human dimensions of the events, along with the real-time struggle to survive the catastrophe. The *arrival* of bison back to the land emphasizes the champions who brought bison back from the brink. In this section, we focus on Theodore Roosevelt and others who arrived onto the scene and launched the great story of American wildlife conservation, with bison at center stage. The great American *awakening* to the preservation of bison is a key part of the rise of an entire national conservation ethic that, at first, was not welcomed but eventually became accepted by a nation in transformation. In this section, we profile the development of new groups and organizations dedicated to conservation of wildlife and wild places, a new idea presented to the world. We especially highlight the American Bison Society, wholly dedicated to

the business of saving this wild and iconic species. The eventual *convergence* of these conservation ideals into restoration activities and civic action by individuals and organizations was not predictable or anticipated by the people involved. They might have remained disparate endeavors but for the efforts of Roosevelt and other conservation champions who connected them into a cohesive movement at a specific time in history. This convergence of people, places and ideas served to prevent the extinction of species and protect critical wildlands, even to the extent that the names "bison" and "buffalo" are now wholly synonymous. This convergence of bison, the buffalo people, visionary individuals, non-governmental organizations and governance has led us toward a future fraught with both peril and promise.

WHAT'S IN A NAME?

Why is there an extensive interchange in the scientific and vernacular use of the names "bison" and "buffalo"? It may be that this interchange contributes to confusion about efforts to conserve the animal, as it wouldn't be unreasonable for a person to wonder why we should agree on complex conservation efforts when we cannot even agree on the animal's proper name! When Linnaeus first classified the bison in 1758 for his tenth edition of *Systema Naturae*, he assigned the animal to the genus *Bos*, which includes domestic cattle. During the nineteenth century, taxonomists determined that there was adequate anatomical distinctiveness to warrant assigning the animal to its own genus, *Bison*, as compared to the true African cape buffalo (*Syncerus caffer*) or Asian water buffalo (*Bubalus spp.*). Indeed, the interchange between the words *bison* and *buffalo* freely occurs in documents written by federal, state and local government; tribes; and private for-profit and nonprofit sectors (e.g., United States Department of Interior Bison Conservation Initiative, Inter-Tribal Buffalo Council, National Bison Association and Buffalo Field Campaign), as well as even between and within science publications.

Historically, the animal we now recognize as the American bison was referred to by Euro-derivatives, such as "bisonte," "buffes," "buffalo" and "buffles." Tribal names also varied considerably, with the Sioux *tatanka* and Blackfoot *iinnii* having received widespread reference and usage. Notwithstanding any scientific taxonomic designation, the common name is now interchanged freely between buffalo and bison without apparent or important conflict in meaning or understanding toward effective stewardship. Indeed, there seems little widespread interest or need to force adoption of either as a single common name, and as such, it appears that the continuing synonymous interchange from the nineteenth century to present has now become the entrenched

preference that integrates prevailing societal agility with a cultural penchant for nostalgia, as Plumb, White and Aune noted in their 2014 comprehensive scientific review of the "American Bison (*Bison bison*)."

HOPE FROM BISON AND HUMAN HISTORIES

By Kent Redford

Bison are, and always have been, complicated animals, despite having limited behaviors and leading the fairly straightforward life of a large herbivore. Rather, the complications come from bison's long history with humans, a path traveled together that has left both parties with intertwined hybrid histories.

Originating in Europe or Asia, the ancestors of North American bison were of great importance to early humans and were featured prominently in cave art such as at the Chauvet Cave in France. Wisent, or European bison, were themselves hybrids between the steppe bison and the auroch, or European ox, the progenitor of European domesticated cattle. Reduced to even fewer numbers than American bison, wisent survived only in zoos, where some were crossbred with American bison, with these hybrid animals bringing the distant lineage back to its place of origin.

North American bison came to this continent across the Bering Strait and survived through climate change and the extinction of other, larger, species of bison. They became vital parts of the lives and economies of numerous Native American groups, a reliance that only increased when horses were (re) introduced to North America. Mounted bison hunting rapidly became such a key part of the culture of Great Plains tribes that many European American observers assumed it had always been so. The ensuing bison culture was a hybrid one of European domesticated animals, Native American lifeways and bison cultural knowledge.

The relentless westward spread of Euro-Americans brought with it decimation of the bison herds, first through the robe trade and then, in the most ignominious of fashions, through the trade in bison bones. All that was left of the tens of millions of bison that once flourished in North America was converted into pigment and fertilizer and even used to whiten sugar. The destruction of the Great Plains grasslands for agriculture was aided by the bones of the very animals that once defined it, a hybrid mixture of prairie past and prairie future.

Although there were clear economic reasons for the European pursuit of bison, some historians have concluded that there could also have been genocidal reasons. Such was the reliance of Great Plains tribes on bison that it might have been that killing the last of the bison made business sense

The new American Bison Coalition logo emphasizing the three principles behind the coalition; promoting unity, resilience and healthy landscapes. *Wildlife Conservation Society.*

and also aided in clearing the land of Native Americans who resisted European colonization of their territories—a deadly hybrid of genocide and extinction.

At the end of the bison slaughter, only a few hundred animals were left in the wild and in private hands. A fancy took hold among some of the private owners that it would be possible to crossbreed bison with cattle to create a breed better able to survive snow, heat, drought and disease. Although such crossbreeding was difficult, there were a number of animals produced that looked like bison but had cattle genes. Some of these same animals became part of efforts to reintroduce bison when the American Bison Society began its efforts to save the bison from extinction. The resulting hybrid animals are common across many conservation and production herds, causing concern among some conservation professionals.

The American Bison Society, established in 1905 and put to bed some thirty-five years later, was re-inaugurated in 2005 by the Wildlife Conservation Society. After stakeholder consultations, the society launched a one-hundred-year vision for the ecological restoration of bison. But this vision was not based on a notion of purity—pure bison, pure people or pure habitat—but on an understanding of the power in accepting the reality of genetic, ecological and social hybridity and proceeding, not despite it but because of it, in restoring bison.

The power of new genetic technologies has revealed to us that even we humans are hybrids—Denisovans, Neanderthals and a handful of other species have all contributed to our genomes. There is power in our hybridity, power to work against the negative attitudes that are so pervasive in our lives and view hope in a sea of invective; power to accept the inevitability of change; and power to use the ecological restoration of bison as a vessel of hope. This hope could inspire action for better lives for humans and for bison. After all, hope itself is a survivor, the last thing left in Pandora's box. Hope itself is a hybrid—of courage, honesty, dreams and, most importantly, action.

SIGNIFICANCE

The relationship between humans and bison is ancient and spans across the entire Northern Hemisphere. A European bison with the common name "wisent" was important in various past cultures, and many cave drawings of bison are prominent across much of the ancient European and Asian landscape. Yet the most renowned connections between humans and bison existed in North America for the past twelve thousand years. With the passage of time, this relationship transcended the physical world and acquired a substantial spiritual dimension. It is a relationship conveyed in creation stories that remain alive still today among native peoples. Many tribes recount stories of bison as coming up out of a cave or hole in Mother Earth. That wellspring of buffalo is reported in oral traditions by tribes from Texas to Alberta. The connection between bison, the earth and native peoples was central to early human life across much of North America.

Many North American native cultures hunted bison, sang songs, practiced ceremonies and shared ageless stories about bison. These stories, songs and ceremonies are found among native people from the canes of Kentucky to the dry sage steppe of Nevada and from the Chihuahua desert of northern Mexico to central Alaska. Many cultures speak to the origin of bison in these ancient stories and connect human well-being to this sacred animal. For example, the Blackfeet and Assiniboines of the northern prairies have many stories of bison as the provider of life, and the animal was central to songs, ceremonies and dances. The Crow, Cree, Cheyenne and Arapaho Nations possess creation stories explaining that bison even predate human

life. Lakotas and Utes share a story of humans arising from the blood clot of a bison. Even far to the south, the Comanche, Apache, Pueblo and Navajo people share ancient stories of bison and practice a buffalo dance. There are bison rituals and clan names among the Caddos, Shawnees and Winnebagos in the middle region of the United States.

Oral and written history clearly describe how bison provided sustenance to a large number of native peoples across North America. In the Midwest and East, the Sauk, Fox, Illinois, Iowa, Miami, Ottawa, Kickapoo and Pottawatomi people were known to rely on bison for food. Hunting of buffalo was documented for Choctaw, Chickasaw and Creek tribes in the southeastern United States. In the far north, detailed accounts from the Athabascan elders described how they hunted bison and indicate that bison were an important source of food. Even tribes in the western mountains, such as the Salish, Kootenais, Umatillas, Walla Wallas and Nez Perce—made annual migrations to hunt buffalo. It is now likely impossible to fully describe all the people groups across North America that depended on this animal for food and sustained their cultures through a relationship with American bison. Consequently, the loss of the American bison in North America had monumental impacts beyond our inadequate understanding of these ancient societies and cultures prominent across North America for twelve thousand years or more.

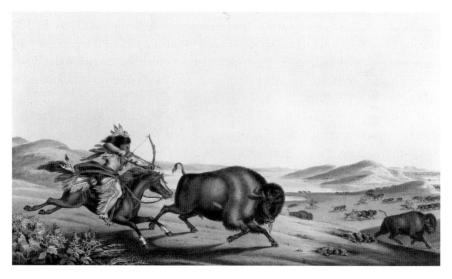

Hunting the Buffalo, drawn, colored and printed in 1837 at I.T. Bowens Lithographic Establishment No. 94, Walnut Street. *Library of Congress.*

Given the depth and breadth of this relationship between bison, the earth and native people groups across North America through song, ceremony and spiritual and physical sustenance, it became no small matter that invading Euro-Americans, by intention or accident, rapidly devastated the species and an ancient lifeway in a mere one hundred years. We should never underestimate the profound impact the great destruction of bison had and still has on indigenous cultures and lifeways.

The plight of the American bison at the close of the nineteenth century was a shameful story in American history and became the catalyst for a new view of the natural world. It may have spawned a new generation of progressive thinkers who were horrified, yet became activated, by this very dramatic destruction and introduced a new vision for nature preservation in contrast to Manifest Destiny. The decimation of bison from a population of more than 30 to 60 million to fewer than 1,000 by 1889 is a troubling story motivated by unrestrained greed and resource exploitation for commercial purposes, the dominating philosophy of Manifest Destiny and misguided U.S. Indian policy. As in all generations, accurate history allows us to look back with clearer vision and try to understand the consequences of these misguided policies and unrestrained natural resource extraction on the Great Plains, American bison and generations of native people whose cultures and lifeways were bound to them.

Several emerging neo-progressives spawned from the unrestrained natural resource extraction of the nineteenth century—such as Henry David Thoreau, John Burroughs, George Catlin, John James Audubon, George Bird Grinnell and Theodore Roosevelt—and began to call for greater understanding, wise resource use and the conservation of nature. Today, we are very fortunate that there was a group of enlightened thinkers that questioned the dominant human philosophies and polices of the day and began a new progressive dialogue about the future of bison, wildlands and other wildlife. The question before us today is whether we can continue a progressive dialogue about how we treat our wildlife and wildlands to advance a more sustainable and just path toward the conservation of nature and protection of our national heritage and interest. Although we have come some distance from the near disappearance of bison and unrestrained natural resource exploitation, there remains a long way to go. This journey requires new generations of strong citizen advocates and champions to carry the heavy load and advance the cause of bison restoration and wildlife conservation.

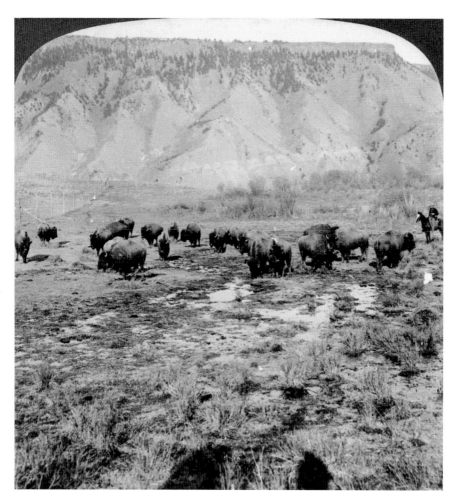

"Last Remnants of the American Bison," Yellowstone National Park, U.S.A. American Stereoscopic Company. *Library of Congress.*

FIRSTHAND WITNESS

There are many stories that reflect on the rich and ancient spiritual and cultural significance of bison to the American Indian. Many of these stories have only recently come to light as Native American spiritual leaders have raised their voices in print and visual media to explain visions, ceremonies and meaning to the broader world. Although some of this information is privileged, in some cases it has become increasingly necessary to share it in

order to preserve the ancient ways of native people and foster respect for rich traditional knowledge. And perhaps the time has arrived when there is greater acceptance in the minds and hearts of the listeners to understand that deeper meaning.

In the early 1930s, one prominent spiritual leader of the Oglala Sioux was *Heȟáka Sápa* (Black Elk). He shared his story with ethnologist John Neihardt, describing his spiritual and physical journey of life on the Great Plains at a time of fundamental transformation encompassing the 1860s through the 1950s. Up to the late nineteenth century, the Oglala Sioux were prominent on the northern Great Plains and a powerful buffalo people. Black Elk arose in stature among his people following a childhood vision that came to him when he was near death due to an illness. Most of his life was then spent acting out the elements of that power-vision, up until the events at Wounded Knee and his death in 1950 at the age of eighty-six.

Black Elk personally hunted wild buffalo in his youth and then witnessed the demise of bison, as well as the spiritual and cultural loss of his people. His sharp mind was always trying to reconcile his childhood vision with the reality he was experiencing in this emerging modern world. He understood that a man who has visions is not able to use the power of them until he has performed those visions on earth for people to witness. Part of Black Elk's vision included a red man who turned into a buffalo and rolled in the earth, creating the good red road for his people to follow. To use the power of the bison, Black Elk had to perform a ceremony from that part of the vision for the people to see, and he sought help from his friend Fox Belly. The ceremony was not a long one, but according to Black Elk, it had great meaning. The ceremony involved placing a sacred tipi around a bison wallow and designing a red road so that the people should walk along it with the power and endurance of the buffalo, while facing the cleansing wind of the world. He also placed a cup of water to the north, so that people traveling the red road into the wind would walk toward the water of life. He and Fox Belly then encircled the witnesses, acting and making the sounds of a bison.

This story from Black Elk illustrates the profound meaning and spiritual connection between bison and native people of the prairie. His vision of life was described in the book *Black Elk Speaks*, which has become an important resource for studying native spirituality. With the rise of Native American activism, Black Elk's life provided insight for many who were interested in their traditional religions and in fostering a growing awareness of how bison remain central to that religion. This has dramatically invigorated the movement to restore bison to American Indian country.

BLACKFOOT AND THE BUFFALO

By Leroy Little Bear and Amethyst First Rider

All societies, in one way or another, lay claim to a territory. Within that territory, a culture arises from a mutual relationship with the land. Hundreds of generations of Blackfoot people have come and gone on the northwestern plains since before and after the melting of the glaciers that covered the northern part of the North American continent. The Blackfeet, in their long relationship with their traditional territory, have developed a unique culture, manifested by their mutual relationship with the land. As stated by Dormaar and Barsh, "Aboriginal ways of living in intimate contact with the earth and experiencing its powers firsthand over thousands of years reinforced an awareness of the indissoluble link between humans and the soil."

For one to appreciate Blackfoot ways, one has to understand the philosophy and paradigmatic aspects of Blackfoot thought. Blackfoot philosophy consists of, and includes, ideas of constant motion/flux; all of creation consisting of energy waves; everything being animate; all of creation being interrelated; reality requiring renewal; and space being a major referent. Lastly, the language, in this case Blackfoot, acts a repository for the totality of the experience and knowledge arising out of the relationships with the territory. "Every worldview is a story about the world and everything in it, a world in which human beings are deeply and inextricably interrelated with all other beings. Each worldview is tied to a unique locality and filled with its own spirituality," as Dormaar and Barsh noted. The totality and synchronization of the paradigmatic aspects of a culture result in certain icons for the society, whether those icons are places, fauna, flora or cosmic.

Every society, sooner or later, develops stories as repositories for the experience, knowledge and explanations to future generations as to the cultural "whys," "whats," "whens," "wheres" and so on. As King wrote, "The truth about stories is that that's all we are." History for the Blackfeet is contained in our stories, ceremonies, songs and places. Many Blackfoot stories have developed over the millennia, telling about the relationship between the Blackfeet and buffalo. Some of these stories revolve around the exchange of a chief's daughter to the buffalo in return for the buffalo making itself available to the people. Some of the stories tell about how buffalo use to eat people and how Creator/Napi changed that around to people eating buffalo.

One of the iconic beings for the Blackfeet is the buffalo—inextricably interrelated to the very being of the Blackfeet. The buffalo not only was a source of material needs for sustenance but also was imbedded in the spiritual lifeways of the Blackfeet. For the Blackfeet, *iinniiwa* (buffalo in Blackfoot) is part of *Sokitapiwa* (People of the Plains), who are part of *Iinniiwa*, culturally, materially and spiritually. The ongoing relationship is so close that we have stories of common consanguinity.

Sustenance-wise, the buffalo is important to the Blackfeet because it provided food for their very survival in a rather unfriendly environment. Stories refer to times when the buffalo was scarce and how the people starved through the harsh winters. One time in the stories relates how the trickster My-stu-bun, Crowfeather Arrow, hid the buffalo from the people and the consequent starvation of the people. Many historical records speak of how the Blackfeet were in search of remnant herds of buffalo during the late 1800s, when the buffalo were near extinction.

From a spiritual perspective, the buffalo has been imbedded into the religious practices of the Blackfeet. The Blackfoot Buffalo Women Society and the Horns Society are examples of the buffalo's spiritual importance to the Blackfeet. Those societies are still present today and go through their ceremonies at the annual sun dance of the Blackfeet.

Iconic symbols—whether they are places, fauna or flora—manifest in many different cultural practices. For instance, during "dog days," the Blackfeet had the communal hunting practice of chasing buffalo over cliffs. Knowledge of the buffalo, its strengths and its vulnerabilities was required to make a hunt successful. When the horse was reintroduced, it was quickly adapted to a new hunting style: the chase. The Blackfeet had specially trained horses for the buffalo chase. This, in turn, resulted in social status for members who had large herds of horses and a number of horses trained to chase buffalo.

The buffalo had a large influence on language. There were not only ways of describing all the parts of the buffalo but also ways of talking about their feeding habits, where they roam, their seasonal rounds, their spiritual aspects and their economic worth. In any society, the disappearance of iconic symbols also means the beginning of the disappearance a culture. One can imagine what would happen to Christians if all Christian crosses were to disappear or if all Christian churches were to be no more. In a modern context, what would happen to our society if all mobile phones were to disappear? Society would likely come to a standstill. From such perspectives, one can begin to imagine the devastating effect the disappearance of the

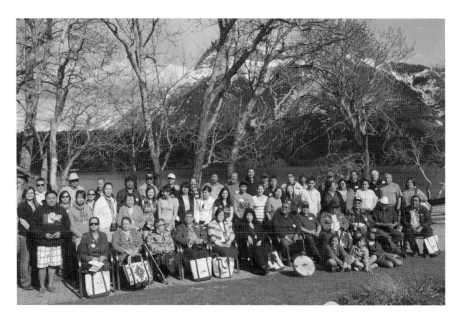

Blackfeet elders at dialogue sessions in Waterton National Park. *Photograph by Steve Zack.*

Bison bull. *Photograph by Hillebrand Steve, U.S. Fish and Wildlife Service.*

buffalo had on the Blackfeet. Even though the beliefs are still imbedded in their very being, the fact that the buffalo is not seen on a daily basis severely weakens the culture of the Blackfeet.

It is for that reason that, in 2009, a small group of elders on the Blood Indian Reserve invited youth to a gathering to remind them about the importance of the buffalo to Blackfoot culture. A number of "buffalo dialogues" were held with the assistance of Wildlife Conservancy Society on both sides of the Canada/United States border. Those dialogues resulted in the "Iinnii Initiative," which speaks to connectedness through strengthening cultural, spiritual and ecological connections with the land and wildlife and the importance of connecting youth to nature. It is a dream of the elders to once again see free roaming buffalo on the plains; this, in turn, will strengthen and revitalize Blackfoot culture. Our elders tell us that while its numbers might be few, the spirit of the buffalo never left Blackfoot territory. That spirit continues to manifest itself in our songs, stories and ceremonies. In other words, Blackfoot culture will once again be fulfilled as the Creator intended.

CHILD OF THE PRAIRIE

By Keith Aune

I experienced a highly imagined reality as a youth growing up on the remote prairies of central Montana, where I played among ancient Blackfeet tipi rings and dug buffalo bones out of Piskuns along the Teton River. During my youth, I could not perceive the connections I would eventually make with the world beyond my small prairie home—wild bison, wild places and the inspiring conservation history of North America. These intersections of time, people, ideas and place only became clear to me after I pursued graduate studies at Montana State University, investigating the American bison in Yellowstone National Park from 1978 to 1980. After completing graduate studies, I began working among the virtually road-less Rocky Mountain Front in my home county of Teton, Montana, conducting grizzly bear research from 1980 to 1989.

After these years of great bear adventures, I moved on to the Montana Wildlife Research Laboratory in 1989, returning to study bison in Yellowstone National Park from 1989 to 2004. Then I served as chief of wildlife research for Montana Fish, Wildlife and Parks, helping to chart a

new and challenging course toward bison recovery for Montana. Shortly after retiring from this post, I went to work for the Wildlife Conservation Society, raising awareness about the ecological restoration of the American bison in North America. At the Wildlife Conservation Society, I focused our site-based conservation efforts on a portion of the Blackfeet Reservation along that same Rocky Mountain Front near where I spent my youth and early career as a wildlife research scientist. As my journey unfolded, it became clear that life indeed had pulled me in a circle and that I had come full turn back to the species, people and places that I was introduced to as a child of the prairie. I am reminded of the wise words of Black Elk, a Lakota holy man, who said, "[E]verything that man does is in a circle, and that is because the Power of the World always works in circles and everything tries to be round."

As I pursued my interests in bison conservation, I grew to better understand the deep relationship between bison and Native Americans. After much instruction from Blackfeet elders and culture leaders, I discovered that this relationship was more significant and meaningful than I had ever imagined as a child. The physical absence of *iinnii* had taken a terrible toll on a vibrant society and culture that had surrounded me most of my life. After some time, the Blackfeet honored me with the name *Otsimi Gistipimi*, which means "Spotted Sorrel." It signified the blending of the red (sorrel) and white (white spots) world. That name best describes my work to restore bison along the Rocky Mountains alongside these exceptional people.

Through knowledge and understanding I gained from a western science education, I also began to fully appreciate the ecological significance of the vital bioengineering that bison bring to the grasslands of the Great Plains. In our arrogance to tame the great prairies and forests of North America, we often introduced great harm and destruction through our ignorance and lack of understanding of functional ecosystems. We now know that keystone species such as bison restore the health and resilience of prairie systems, and their absence for more than one hundred years has diminished these landscapes.

Fortunately for all of us, there were many dedicated individuals from the nineteenth century forward to present times who championed the cause of restoring bison in wild places. One of the most prominent of those was none other than Theodore Roosevelt, who was perhaps the single most influential person launching an entire conservation movement for the nation, including remarkable efforts to save American bison. I hope to do my part to emulate these great legends of conservation and carry forward the legacy

they created. This book is part of a personal quest to tell the story of bison conservation, connect the circle around mankind's ongoing efforts to save bison and extend the legacy of wild bison conservation into the twenty-first century and beyond.

SMELLS LIKE BUFFALO SPIRIT

By Glenn Plumb

Their smell changed everything. I was sixteen years old in the summer of 1973 and part of a military family who moved around a lot. So, I collected stuff that I could pack quickly and carry along: comic books, stamps, small models, coins and smells. Strange as it seems, I paid attention to smells. I guess I collected them like memories so that I would not forget where I had come from. I knew from firsthand experience the smell of a Libyan sirocco; the hot racing tires at the Indianapolis 500 speedway; the snow melting high in the German Alps; the jet fuel on afterburner beyond the military flight line; the acrid smell of fresh blood and burnt flesh from branding calves; the mélange of rotting smells of Everglades mangroves; the sweet, unpleasant aroma of pot at a rock concert; the cows in the pen; the mixed odors of fear, gun oil and bitterly cold predawn while deer hunting high in the Black Hills; my mother's chocolate cake; the fresh-mown June hay and blooming Russian olive; the moldering summer midnight in a Midwest oak forest; our cat; and warm beer. I had a very large collection of smells from across a pretty large swath of the world that helped me to figure out my identity as an experiential young person. But I had never before encountered the smell of bison moving across the open prairie.

In short, that summer a fellow named Don Hight had decided to graze his private buffalo herd on fresh grass near the town of Buffalo in northwest South Dakota. He was fifty-three years old and a man of spirit. He had grown up in a ranching family in the White River country. He served as a paratrooper in Europe during World War II and had captured the world's attention in 1962 by trailing more than 1,800 head of cattle from Westover to Winner in southern South Dakota. Then he was featured in an episode of the *Rawhide* TV series. Well, I didn't know any of that in 1973. But I knew that Buffalo was north of Spearfish and was a pretty good long distance from Don's home place near Murdo, along the White River. I don't know if Don

considered trucking them, but I figure he must have known how expensive and hard that would be—and probably the haulers weren't too keen on it either. Instead, he decided, with the help of Brady O'Rourke, to trail a herd of 450 buffalo three hundred miles to summer pasture and pick up some volunteers along the way. All he had to do was go ahead of the herd, talk with landowners about allowing him to cross their places and trust to the good will and enthusiasm of the prairie people along the way. He simply opened the gate and put his plan in motion!

Along their route, and southwest of Quinn, Willard (Bud) Bloom, my buddy Jeff's grandpa, owned the Bloom Ranch, namesake of Bloom Basin, north of then Badlands National Monument. Jeff would sometimes invite me to the ranch, where I was able to help with chores, learn some basic skills and generally having some serious fun. Anyway, during that summer, I was able to join Don's buffalo drive with Jeff (in a picture of us, he's at far left with the polka-dot cap he always wore, and I'm just to his right,

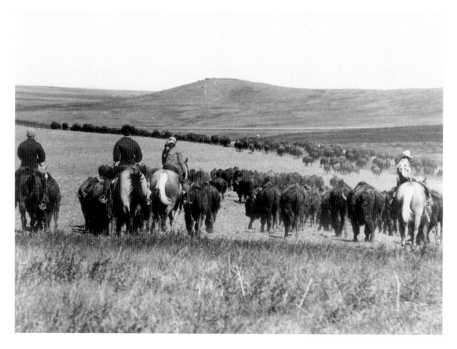

Three hundred miles, 450 bison and a lot of guts! In 1973, rancher Don Hight walked a bison herd from his ranch near Murdo, South Dakota, to summer pasture near Buffalo, South Dakota, with the help of friends and neighbors along the way. Author Glenn Plumb is shown second from left. *Photo by Tom Stanton,* Fort Pierre Times, *Fort Pierre, South Dakota, June 1973. Private collection of Jeff and Kathy Bloom, Rapid City, South Dakota.*

by his side, where I loved to be, in the trusty jean jacket that I still wear in the fall). We rode flank and drag on the herd, and I will never forget the intense sensory delights of going down the long trail tired, sore and thirsty on horseback, amid the dust, smell and noise of a herd of hot and likewise tired and thirsty bison.

The smell literally blew (into) my mind. It was transcendent! A long dark ribbon of smell. matted hair, hot breath, urine, dung, dust, trampled soil and grass, crushed cactus, blowing snot and dripping saliva. The smell of my horse and hot saddle blanket that kept shifting to the side. The smell of my own body as my left knee grew steadily more sore until I had to hang it over the saddle horn, trusting that I wouldn't get thrown by a fussy horse or hooked by a fussy buffalo. It was like I was struck by a lightning bolt of smell! An utterly new kind of smell. The kind of smell that compels you to sit straight up and pay attention. The smell of all smells! It redefined my world and seemed to relegate the rest of my collection to only a prelude to what the world truly could be like.

On that trail, my understanding of everything changed. I encountered a phenomenon I had never imagined. I can still recall the smell of hundreds of buffalo slowly walking north over the horizon, somewhere north toward Elm Springs, as I wondered about crossing the Cheyenne River. Prior to that summer, I thought the world was large and full enough, as we ran like wild things near and sometimes inside the "park," as we called it, trying to be a reliable hand, learning to use a rope, branding calves, putting up hay, shooting prairie dogs, looking for fossils and beer, rodeoing and generally trying to stay just on the good side of real trouble.

Later that year, we moved again, and my lifeway continued moving forward across the decades in new directions, to Washington, D.C., West Virginia, Texas, Saudi Arabia, Russia, China, Central Asia, East Africa and eventually back out west, amid the prairie for good. But as time moved along, I got into a way of thinking, re-thinking and re-re-thinking about open-range buffalo. When I first went on that buffalo trail, I could somewhat understand the idea of me running wild and free, but I simply could not yet comprehend an idea of wild and free-ranging buffalo. Could one actually walk over the horizon for a few weeks on end? Could one actually embark on an uncertain journey, entirely dependent on being able to engage the good will of strangers? Was there still room in the world for large assemblages of large-body-size wildlife living across very large swaths of the country? The questions and curiosity have never faded. That hot summer of 1973 still smells like buffalo spirit.

DISAPPEARANCE

Where do bison come from, and why do they live in large herds? How did they come to near extinction after millions of years of evolution? The evolutionary biology of bison is well described in many scientific publications on which we draw for this short synopsis. A fairly thorough summary for the more curious reader is found in the *Bison Status and Guidelines Report*, published by the International Union for Conservation of Nature in 2010. According to that review, some form of bison has existed in the Northern Hemisphere for more than 2 million years. Paleontological data indicates that the genus *Bos* (wild and domestic cattle) and *Bison* shared a common ancestor between 1 million and 1.4 million years ago. Bison did not enter North America until the middle of the Pleistocene between 300,000 to 113,000 years ago. Many of the early forms of bison were much larger, more impressive and wore incredible head gear in the form of very large horns. The common ancestor of all modern bison was the majestic steppe bison, which dwarfed all modern versions and lived 100,000 to 12,000 years before the present. The evolution and distribution of various bison species and subspecies present a complex story, which was shaped, in large part, by climate, which influenced bison habitat that shifted widely with advancing and retreating continental ice sheets. The ultimate result of this evolutionary history today is two species, the European bison and American bison, and two recognized subspecies of American bison, wood bison and plains bison.

An amazing feature of bison is the rapid physical and social development of calves. As a product of the big open prairie filled with large predators,

the evolution of this behavior was essential to species survival. Calves begin grazing and drinking water within a week of birth but continue to nurse for seven months or longer. Their distinct neonate color of red is highly contrasted with the summer green background of grasslands, but this pelage rapidly darkens after two and a half months and gradually becomes dark chocolate brown, blending into the larger bison social groups. These young calves are weaned between seven and twelve months of age and rapidly become independent and able to fend for themselves if provided the shelter and comfort of a social group.

The timing of birth among the herd also provides better group care and predator protection to bison herds when it is synchronized with plant growth and phenology. The majority of births take place in the spring (April–June), and there appears to be some degree of local synchrony in birthing, with 80 percent of births occurring during a one- to two-month period. Birth synchrony is especially noticeable in northern populations of bison, where wolf predation on calves can be high. Birthing may occur earlier when there is an earlier onset of spring plant growth. Also, bison in poor nutritional condition or with debilitating diseases may calve later and/or show low synchrony in birthing. This important biological feature of bison teaches and reinforces the necessity for strong social bonding of groups and is manifest in female-led social groups.

Female-led nursery groups serve to protect calves through dilution of predation and increased vigilance by a group. Bison females use quick charges or steady advances to defend a calf against threats. Specific examples have been documented where an isolated plains bison female vigorously defended her calf from a grizzly bear, even though the bear was ultimately successful in killing the calf. Also, a mixed sex and age group of adult plains bison has been seen to respond to an approaching grizzly bear by facing the bear in a compact group, with the calves running behind the adults. Adult females and other members of mixed sex and age groups may cooperatively protect calves from predators, and many field scientists and naturalists have described how calves moved to the center of the bison group during wolf attacks.

Post-weaning mother-daughter associations continue due to maternal contributions to maintenance or proximity. Daughters benefit through more time in the center of groups and less displacement when their mother is in the group. The longest mother-calf associations are with female offspring that may remain with their mother through three summers, which ensures that group knowledge is retained. Male offspring may remain with their

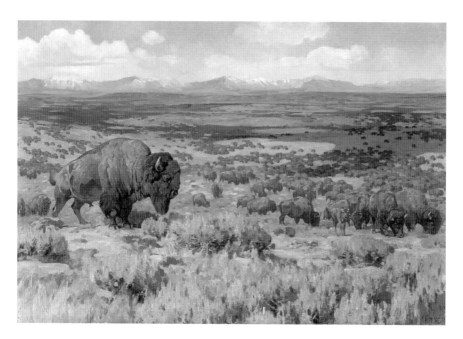

The Days of Bison Millions (looking west toward the Wyoming Range), painting by Carl Rungius, 1917. *Wildlife Conservation Society.*

mother through two summers. Remaining with mothers and other adult bison enables the transfer of herd knowledge to all members of a complex bison society.

The American bison, in its modern form, extends back at least twelve thousand years before the present. The often-forgotten aspect of this animal in our modern world is its long-standing resilience across North America, despite variable climatic conditions and a determined human presence on the continent. Few other large mammal species survived through the last twelve thousand years, while bison became a dominant feature of North America. During the recent millennium, modern bison existed across nearly all of North America, and millions ranged in the Great Plains at the heart of the continent. Few people realize bison were actually quite common east of the Mississippi and occupied grasslands from Mexico to central Alaska. Even in recent times, they were relatively abundant in places we do not normally associate with bison. They were common in Pennsylvania, George Washington killed a bison in Virginia and mariners occasionally saw them on the coasts of Florida and in the Gulf regions of the United States. They were very abundant in the tall grass prairies of the Midwest, especially around Illinois, Kansas, Nebraska, Ohio and Kentucky. These gregarious

bison herds even penetrated many valleys of the Rocky Mountains, into western Montana, Idaho, Colorado, Oregon and even Washington. Bison could thrive at any elevation, from desert grasslands to the high plains and even seasonally high-elevation alpine habitats at the top of the Rocky Mountains. But of course, the heart of bison country was the Great Plains. This terminology, the "buffalo heart," was actually used by plains people to describe the center of bison range, and it may be that they better understood that like the heart of living things, the Great Plains were the pump for the continental bison population that propelled animals out to the various regions of the continent. Nonetheless, this animal was abundant across a wide range of North America.

To fully explore the modern history of the American bison in North America before European contact, we must consider the places inhabited by humans and bison for the past twelve thousand years. The temperate grasslands in North America formed as the result of great receding inland seas. These grasslands were a vast area encompassing an area of more than 1.4 million square miles, with most of it sitting squarely in the middle of the continent. This area was a virtual ocean of grass, and these grasses, up to 140 species of them, were the lifeblood of the great prairie ecosystems that were filled with bison and other grazers. These large and influential herbivores, in turn, helped shape habitat for other wild animals via their bioengineering nature and nutrient cycling. The story of these great oceans of grass with large grazers and human hunter-gatherers is filled with significant change over prehistoric and historic time. For about twelve thousand years before the present, there were many changes in the density of humans who occupied this space, and many dynamic cultures and lifeways prospered. These human cultures varied immensely over time in their relationship with and understanding of nature. They each developed unique ways to hunt, gather and practice ancient forms of agriculture to thrive. Today, we recognize that there were prominent changes in the abundance of large mammals; the mobility and ingenuity of humans, such as the reintroduction of the horse; and significant advances in the technology of hunting weapons or methods during this twelve-thousand-year period. It would be wrongheaded to imagine that the time before European contact was static or stable, or that it would remain unchanged as we move forward in time. The past and the present are filled with frequent variation in natural forces, including great fluctuations in climate, progressive evolution of human society and shifting animal abundance or distribution.

However, the basic drivers behind this nature-based dynamism were permanently altered following the discovery of the New World by Europeans, who brought advanced technologies empowering them to significantly influence or even dominate nature—power we still possess and have even enhanced further yet. The appearance of the Anthropocene epoch, a proposed time when humans became the strongest influence on the earth's geology and ecosystems, is now thought to have arrived and is rapidly affecting and shaping the future of North America, especially the forests, grasslands and wildlife within it.

The first European to venture into the Great Plains of North America was Francisco Vasquez de Coronado, who was dispatched from Mexico City in 1540. Although Coronado did not find his imagined city of gold, he did describe a wilderness that "teemed with millions upon millions of strange humpbacked cattle." Early descriptions of this Great Plains area were not flattering and often called this area the Great American Desert. It was indeed drier than most Europeans had yet experienced, and this may have created a mistaken impression among them that it was worthless and provided no value to modern civilized man. However, they eventually came to recognize the value of this land and its rich prospect as the future breadbasket of the world. Unfortunately, that notion eventually spoke to the demise of American bison and caused its near extinction.

The first Euro-Americans to travel west came from either a recent European immigrant background or grew up in the rich eastern forests of the newly formed United States. The notion of a rich and bountiful Great Plains was not yet conceivable to them, as they could only see the vast emptiness (lack of people) and the dominant occupation of these lands by wild animals and people they did not understand. The notion that wild bison ranging across the great grasslands in vast numbers were a sustainable food resource or the perfect cow, or that they had contributed to healthy grasslands for more than twelve thousand years, was not possible for them to know. Wild bison moved frequently and for long distances as they had for millennia, and these new Euro-American invaders did not, and could not, understand the incredibly vast ecosystem or adapt readily to it as Native Americans had for twelve thousand years. Bison and myriad native cultures were operating in an ocean of grass and interrupted forests that functioned best when bison and other wildlife were free to move and range at monumental scales. The sheer operating scale of this system was so great that it confounded the small-scale mindset of these newcomers from the east. So, in human ignorance and arrogance, they

chose to completely bypass it, seeking rather forested lands farther west or to convert it to their version of productive farmlands, from the perspective of a European descendant who knew how to grow crops. They could not imagine working in a wild system that functioned at large scale without man's domination of it.

The hurricane winds of great change were thrust on American bison and the wildlands of the Appalachians almost immediately after the formation of the United States in 1776. First arose great contests for the rich fur trade in the rivers and lakes of the West. Then came the insatiable desire for more land-driven expansion of the first pioneers migrating out of the original colonies, facilitated by a series of treaties and land cessions with Indian tribes between 1780 and 1810. These agreements ultimately forced the westward movement of tribes or full assimilation of native peoples, thereby enabling settlement by Euro-Americans to the borders of the Mississippi River. Then came the Corps of Discovery exploration in 1804–6, across the vast continental expanse, that opened a new chapter in United States history, fueling the appetite for more free lands for adventuresome settlers.

What followed was a great territorial expansion into the western United States from 1812 to 1860. Thomas Jefferson articulated the dominant vision that was behind westward expansion when he wrote to James Monroe, then governor of Virginia, outlining his dream that "white settlers, sturdy, independent farmers, would increase in numbers to eventually cover the whole northern, if not southern continent, with a people speaking the same language, governed in similar forms, and by similar laws; nor can we contemplate with satisfaction either blot or mixture on that surface." The destiny of the continent had been sealed by increasing westward human migration, growing settlement and more Indian treaties and land cessions that eventually secured a Euro-American nation from ocean to ocean. At about the time of Theodore Roosevelt's birth in 1858, the fate of the American bison, Native Americans and the natural wild prairies on which both depended had already been determined. The outlook was depressing to the nativist.

The near extinction of bison by 1890 was the result of multiple factors, including disease, overhunting for commerce and conversion of habitat for agriculture. It seems unfathomable to us in contemporary times, and was initially inconceivable to people of that time, that in a mere forty years, 30 million to 60 million bison would be reduced to only 1,000 by 1889. How could that be? What magnitude of decimation could bring to an end more than twelve thousand years of evolutionary momentum?

Despite inherently high reproductive rate, the great slaughter equated to 2 or more bison killed nonstop every minute, every day, every month, every year, for forty years (eleven presidential administrations or twenty sessions of the House of Representatives) between 1860 to 1900! Much of the destruction was brought about by through commercial bison hide hunting for industrial-strength leather belts for steam engines, for public consumption of buffalo tongue as a food delicacy and sheer intentional wanton waste. In Theodore Roosevelt's own words, used to describe the scene after the crime, he wrote, "No sight is more common on the plains than that of a bleached buffalo skull: and their countless numbers attest to the abundance of the animal at a time not so very long past. On those portions where the herds made their last stand, the carcasses, dried in the clear, high air, or mouldering skeletons abound." In more graphic descriptions of the carnage, Roosevelt wrote in 1885, "A ranchman who at the same time had made a journey of a thousand miles across Northern Montana, along the Milk River, told me that to use his own expression, during the whole distance he was never out of sight of a dead buffalo, and never in sight of a live one." By the time of Roosevelt's travels out west, the extermination of the American bison was nearly complete and little could be immediately done to fully reverse the damage.

The impact of livestock diseases by the introduction of cattle and sheep to the Great Plains is one other aspect of the great destruction of bison that is often overlooked. Just as the smallpox and other diseases devastated native people, wild bison were exposed to livestock diseases, such as bovine tuberculosis, brucellosis and anthrax, as well as a host of parasites. Wild bison in North America did not have the immune capacity to fend off these European livestock diseases and succumbed to them readily during the development of our nation. The impact of disease had a significant additive effect on the already declining populations of wild bison.

The final blow to bison numbers and the greatest hindrance to their recovery was, and is, the permanent conversion of grasslands to croplands. The loss of the temperate grasslands around the world is very well documented, and less than 10 percent native grasslands are protected and preserved in their natural state. This is because these are the very lands that are best suited to agriculture development and useful for feeding mankind. The great plow-up of the Great Plains for corn, wheat, barley, alfalfa and other crops permanently sealed the fate of the American bison except in a few strongholds where intact grasslands yet remain and bison could be restored.

Critical to the history of bison and, ultimately, its near extermination and eventual recovery was the inevitable collision between two powerful human cultures: Native Americans of the so-called New World and invading Euro-American from the Old World. This was, and remains, a clash between two competing cultures, trying to exist on the same continent at the same time. It was a battle between a presumably tamed world and a wild world, involving two cultures with entirely different understandings of man's relationships to the natural world. The Native American worldview was timeless, coming from thousands of years experiencing and observing nature, and contrasted sharply with a quantum worldview from the Old World that focused on manipulating and dominating the natural world to meet the needs of mankind, fully utilizing human ingenuity to guide and enhance such manipulation. Native Americans considered man as one part of a large natural world, where man was more often controlled or even defined by the world. In contrast, the invading Euro-Americans viewed man as the central figure of the world who defied nature and exploited it for human interests. Native American thinking emphasized the natural flow of energy through all things in the world, while the Euro-world emphasized that the matter found in the world could and should remain static and manageable. A concept of depleted nature and limited natural resources was not central to a worldview of Euro-Americans moving west, who rather practiced Manifest Destiny as they began to rapidly reorganize the Great Plains and mountain valleys across North America.

The Euro-American invaders concentrated on owning or manipulating that matter (natural resources such as gold, grass or timber) when they occupied North America. Native Americans saw all things in the earth (humans, animals, rocks, trees, soil and more) as animate and equal in stature to humans, while the new invaders considered living beings (man and animals) as the only animate features of the world while matter was inanimate and destined to be acquired. These two views would meet more casually and quietly for some time, as Euro-Americans gained an early foothold on the East Coast and then moved westward. Eventually, though, the newly arrived people executed a more powerful and subjugating invasion, aimed at possessing and managing the entire new world from coast to coast. And to furthermore exacerbate the contest, the invading people attempted to replace the worldview of the subjugated native people with the old-world model (European) for living on earth. Given the difference between these two distinct worldviews and the eventual shift in power toward the dominant invading Euro-American culture, it is not surprising there were significant

consequences to natural resources and species such as bison. Although it was these two human cultures that clashed over wild nature and competing ways to live with and relate to the natural world, species like the American bison bore a catastrophic consequence to that contest. This prominent change in the fundamental relationship between man and nature during the past four hundred years is central to understanding the story of the near extinction and eventual recovery of American bison, as well as the future role of human actors in that story.

LEGISLATIVE FAILURE TO PRESERVE AND PROTECT

From 1870 to 1900, there were several attempts to bring federal legislative authority to the protection and preservation of the American bison while it was being systematically slaughtered. In 1889, Dr. William Hornaday, curator of the Smithsonian Museum, carefully summarized Congressional deliberations to preserve and protect the wild bison. At that time, he recorded various Congressional efforts between 1871 and 1874 when both houses of Congress ultimately succeeded in passing a suitable act that went to President Grant but was never signed into law. During this interval, Arizona first proposed legislation to protect the buffalo from wanton slaughter and ultimate extinction on March 13, 1871, when Mr. McCormick introduced H.R. 157, "A Bill to Restrict the Killing of the Bison," that read, "*Be it enacted, etc.*, That, excepting for the purpose of using the meat for food or preserving the skin, it shall be unlawful for any person to kill the bison, or buffalo, found anywhere upon the public lands of the United States; and for the violation of this law the offender shall, upon conviction before any court of competent jurisdiction, be liable to a fine of $100 for each animal killed, one-half of which sum shall, upon its collection, be paid to the informer."

Subsequently, in February 1872, Mr. Cole, of California, introduced in the Senate a resolution that received unanimous consent: "*Resolved*, That the Committee on Territories be directed to inquire into the expediency of enacting a law for the protection of the buffalo, elk, antelope, and other useful animals running wild in the Territories of the United States against indiscriminate slaughter and extermination, and that they report by bill or otherwise." Shortly thereafter, in February 1872, Mr. Wilson, of

Massachusetts, introduced Senate 655, which restricted the killing of the buffalo on the public lands; it was read twice by its title and referred to the Committee on Territories. In January 1874, Mr. Fort, of Illinois, introduced H.R. 921 to prevent the useless slaughter of buffalo within the Territories of the United States; it was read and referred by the Committee on the Territories to the House, with a recommendation that it be passed.

As Hornaday summarized:

> *The first section of the bill provided that it shall be unlawful for any person, who is not an Indian, to kill, wound, or in any way destroy any female buffalo of any age, found at large within the boundaries of any of the Territories of the United States. The second section provided that it shall be, in like manner, unlawful for any such person to kill, wound, or destroy in said Territories any greater number of male buffaloes than are needed for food by such person, or than can be used, cured, or preserved for the food of other persons, or for the market. It shall in like manner be unlawful for any such person, or persons, to assist, or be in any manner engaged or concerned in or about such unlawful killing, wounding, or destroying of any such buffaloes; that any person who shall violate the provisions of the act shall, on conviction, forfeit and pay to the United States the sum of $100 for each offense (and each buffalo so unlawfully killed, wounded, or destroyed shall be and constitute a separate offense), and on a conviction of a second offense may be committed to prison for a period not exceeding thirty days; and that all United States judges, justices, courts, and legal tribunals in said Territories shall have jurisdiction in cases of the violation of the law.*

Mr. McCormick, from Arizona, had made clear his own motivation by having read into the House record, "The buffalo slaughter, which has been going on the past few years on the plains, and which increases every year, is wantonly wicked, and should be stopped by the most stringent enactments and most vigilant enforcements of the law." For some members of Congress, the record shows that these legislative efforts were intended to prevent the wanton destruction of the wild bison only in order to preserve the opportunity for reasonable chase and hunt of the buffalo. Ominously, Hornaday also noted that the secretary of the interior had already communicated to the House that the civilization of the American Indian was impossible while the buffalo remained on the plains. Ultimately, despite Senate and House support in 1874, the proposed legislation failed because President Grant refused to sign it into law.

As described by Hornaday, in January 1876, Mr. Fort introduced H.R. 1719 to "prevent the useless slaughter of buffaloes within the Territories of the United States," which was referred to the Committee on the Territories, which reported back the bill without amendment in February 1876, as its provisions were identical with those of the bill introduced by Mr. Fort in 1874 that had previously passed both houses. Mr. Fort's motivations were articulated clearly that "the intention and object of this bill is to preserve them [the buffaloes] for the use of the Indians, whose homes are upon the public domain, and to the frontiersmen, who may properly use them for food....They have been and are now being slaughtered in large numbers....Thousands of these noble brutes are annually slaughtered out of mere wantonness....This bill, just as it is now presented, passed the last Congress. It was not vetoed, but fell, as I understand, merely for want of time to consider it after having passed both houses." Mr. Fort also stated that while the government was already furnishing cattle for the Indians, the buffalo was being wantonly destroyed and should rather be put to good use. Records of committee discussion also show the wide differences among the House members, as some thought that while the intention of the bill was good, it would be difficult to enforce and a hardship to frontier people. Others thought the bill was poor policy in that the sooner the buffalo was exterminated the better, while others felt only that to exterminate the buffalo would be to make the "red man" more wild and savage than he was already. Ultimately, the bill was again passed by the House and reported to the Senate in February 1876 and again referred to the Committee on Territories, whence it never returned, following the shocking events of June 1876 at the Little Bighorn River.

History shows that multiple efforts to help save the American bison were advanced to the U.S. Congress and various state legislatures for four decades before much success was achieved. The leaders in U.S. and state governments reflected the dominant philosophy of Manifest Destiny during the nineteenth century and were very reluctant to institutionalize new conservation ideas and practices emerging from the progressives and reformers speaking on behalf of nature. Specifically, they were very reluctant to bring bison back from near extinction when a serious policy of extermination had been vigorously pursued to help subjugate native people following the American Indian wars. The failure of governance to preserve and protect nature forced the efforts of individuals and nongovernmental organizations to pursue conservation measures, hence a suite of conservation organizations emerged at the turn of the nineteenth century, including the New York Sportsman Club (1844), Boone and

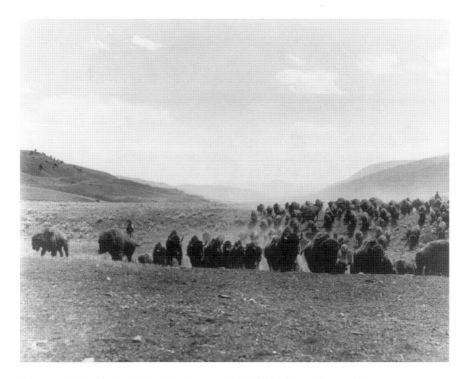

Stampeding buffalo herd chased by hunters, 1917. *J.E. Haynes, Library of Congress.*

Crockett Club (1887), New York Zoological Society (1895), Campfire Club (1897), American Ornithologist Union (1896), Audobon Society (1904) and the American Bison Society (1905). Through these citizen clubs, persuasive lobbying sprang into place to influence Congress and state legislatures to institutionalize wildlife protection and preservation.

LEGACY BISON: BIG MEDICINE, AN ENDURING SPIRITUAL SYMBOL

A white buffalo or bison is an American bison that displays white fur and is considered sacred or spiritually significant to Native Americans. A white buffalo born by natural means is extremely rare and is thought to occur naturally only once in 10 million bison. The birth of a white bison was viewed by many Native Americans as a sign of supernatural power. A white

buffalo often may be visited for prayer and other religious rituals. There are several important stories that signify the importance of the white buffalo among native people. The Blackfeet considered white buffalo as the property of the sun and "good medicine." For the Lakota people, White Buffalo Calf Woman (*Lakȟótiyapi*: *Pte Ska Win* / *Pteskawin* / *Ptesanwi*) is a sacred woman of supernatural origin central to the Lakota religion as the primary cultural prophet. According to oral tradition, she brought the "Seven Sacred Rites" and a sacred ceremonial pipe to the Lakota people. The White Buffalo Cow Society (*Ptī̀ ̀ake Ō ǩat'e*) has historically been the most respected women's society among Mandan and Hidatsa peoples. The women of this White Buffalo Cow Society perform the buffalo-calling ceremony. The Cheyenne people slew a white buffalo on the night the stars fell (during the Leonid Meteor Shower) and penned a treaty on its hide.

In May 1933, a white bison calf was born on the National Bison Range in western Montana and nicknamed "Whitey" by refuge staff. But as time passed, he was given the name "Big Medicine" from the Salish and Kootenai tribes of the Flathead Valley in recognition of his sacred power.

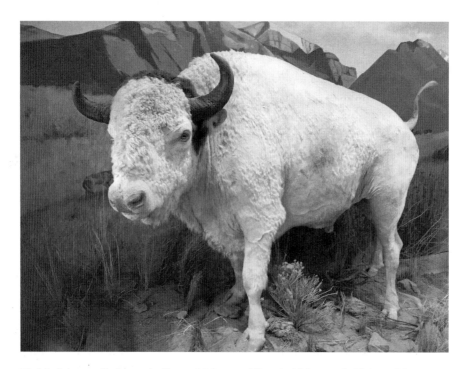

Big Medicine on display at the State of Montana Historical Museum in Helena, Montana. *Photograph by Keith Aune.*

His top knot of dark hair made him unique among recorded white bison, and he was considered a modern legend. While alive, he was the second-most popular tourist attraction in all of Montana, after Yellowstone National Park. Big Medicine was fed a special diet and received special care throughout his life. He was kept on display in a special herd and fathered a white bull calf in 1937 that was sent to the National Zoo in Washington, D.C. Most white bison do not live very long, but Big Medicine lived for twenty-six years, which is very old by bison standards. He lived up to his name, as he stood six feet at the hump, was twelve feet long from nose to tail and weighed 1,900 pounds. After his death on August 25, 1959, his hide was tanned and mounted for display in the State of Montana Historical Museum in Helena, Montana. His figure was dedicated in a ceremony at the Montana Historical Society on July 13, 1961, where he permanently resides to this day.

LEGACY BISON: SANDY, THE LAST WILD CALF FROM THE MONTANA PRAIRIES

During the spring hunting expedition by William Hornaday to Montana in 1886, a live male bison calf was captured. In the quest to find the few remaining bison in central Montana, the expedition came upon a calf that could not keep up with its mother in the big open prairie near Phillips Creek, north of Miles City, Montana. Hornaday reported, "We found him in a barren hollow between two high buttes, as lonesome looking a waif as ever was left to the mercies of a cold world....To all of us he was a genuine curiosity....His thick wavy coat was of a uniform, bright sandy color, and 'Sandy' he became from that moment."

It was an important sign to the party that a bison herd remained and was reproducing. The weak calf was carried back to camp on a horse and kept there until it could be shipped back to Washington, D.C., that June for display at the National Museum. Hornaday had long been interested in exhibiting live animals as opposed to just taxidermy specimens, but he did not think it possible to do, as bison were rapidly disappearing. Sandy was shipped back to the National Museum by train and was penned up on the lawn of the National Museum (today the Arts and Industries Building). The calf remained in his enclosure during the summer months of 1886 and became quite a spectacle for the public. From the eyes of a wild bison calf,

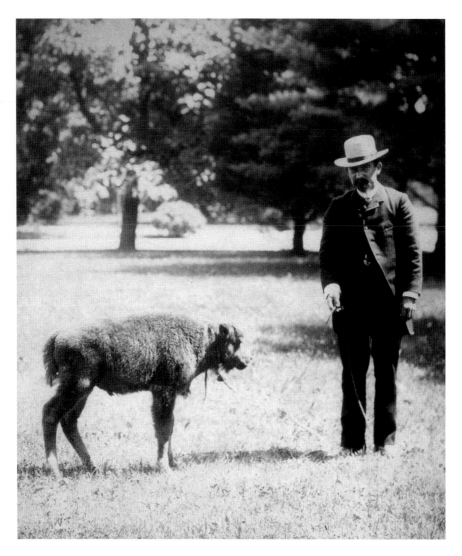

Dr. William Hornaday with Sandy, the buffalo calf, in front of the National Zoo in Washington, D.C. *Wildlife Conservation Society Library and Archives.*

this adventure had to be very stressful, and symbolically, Sandy represents the loss of truly wild bison and their eventual reduction to captivity.

Over the course of a few weeks, however, Sandy began to acquire a humped back, more bulk and increasingly unruly tendencies. Andrew, Sandy's human attendant, had to cope with the fat, fractious animal. Hornaday described the violent confrontations between the animal and

human keeper in a *Cosmopolitan* magazine article in 1887: "Going up to the now quite demure looking calf Andrew muttered, 'Confound your hide you son of a gun, If I wasn't so attached to ye, I'd kick the stuffing out o' ye right now.'" Unfortunately, Sandy died on July 26, 1886, presumably from eating too much damp clover. Hornaday decided to incorporate Sandy into the museum's unfinished taxidermy group of buffalo, draping his treated hide over a wood and clay form. It could be that Sandy was just not willing to give up his wild nature for a life of captivity. Nonetheless, he represents one of the last of the truly wild bison calves, and his legacy is now expressed as a mounted specimen of the bison family group that went on display at the National Museum in 1888.

Before Sandy's untimely death, Smithsonian visitors had enjoyed watching the calf's daily activities through the fence of his pen near the National Museum. Inspired by this public interest, Hornaday established a Department of Living Animals at the Smithsonian in 1889 as part of the dream to memorialize the American bison. He eventually acquired six live bison for display and felt it was one way to atone for the destruction of the wild herds in North America. A few years later, in 1895, Dr. Hornaday teamed up with Theodore Roosevelt to create the New York Zoological Society and establish one of the first captive bison herds for conservation. Perhaps his plan for a captive bison herd was prompted as a result of his experience with Sandy, the last wild bison calf.

ARRIVAL

B y the turn of the nineteenth century and beginning of the twentieth century, the quest to save bison had arrived. It was brought about mostly by citizen action at first. Indeed, legislative and government failure to protect the dwindling bison population can be seen as an important catalyst for such citizen action. Progressive thinkers and determined men and women were listening to the voices of nature and self-organizing to save wildlife from extinction. However, the development of this new thinking had actually evolved over many decades and finally rooted into the conscience of new champions for the preservation of bison by the early 1900s. To better understand this time of transformation in our American history, we can examine the life of Theodore Roosevelt, who was instrumental in the conservation movement from that period.

THE MAKING OF A CHAMPION
FOR AMERICAN BISON

Theodore Roosevelt was the seventh generation of his clan in America. His distant ancestors emigrated from Holland to Manhattan, New York, in 1644, and family history indicates that they were always active in the republic. Perhaps the Iroquois philosophy of "Seven Generations Thinking" has brought some bearing on the transformative thinking expressed by Roosevelt

and his family. It is interesting to consider that when Theodore was living, our country was being led by many others from that seventh generation of immigrants to the continent. The concept of Seven Generations Thinking was an ideology prevalent in many Native American tribes and a way of thinking and living centered on a traditional culture, democratic decision processes and strategic thinking about the present and future of the world. Under that concept, three generations past are responsible for shaping the current generation, which, in turn, is responsible for helping to shape the next three generations to come. This way of thinking emphasizes that "business" decisions for tribes have ramifications far beyond economics of a place and time. Decisions transcend the cultural, social, historical and spiritual perspectives of native people living at any time. Its temporal complexity means it takes somewhat longer to build community consensus and requires careful planning to preserve what could easily be lost. This way of thinking requires a meshing of traditional and emerging practices.

There is no doubt that Theodore, a seventh-generation American Roosevelt, was a product of family traditions, worldly knowledge, established wealth and social privilege that was created by the previous Roosevelts in America. The Roosevelt social and financial capacity provided great opportunity for young "Tweedie," as he was called by his family. He enjoyed a resource-rich and nurturing environment that enabled him to discover nature, explore the world and interpret that world from a more romantic viewpoint than most people living during that time or preceding it. His childhood and privileged condition coincided with a tremendous period of rapid world change and the evolution of modern science. Roosevelt was raised during America's Gilded Age, the period after the Civil War (1865–1901) when Reconstruction gradually led to unprecedented economic, territorial, industrial and population expansions rooted in industrialism, railroads, banking and real estate speculation. These changes were critical to the development of Theodore Roosevelt's personal philosophy about human relationships with nature and wildlife.

There were many family members who influenced a young Roosevelt and may have directed him, intentionally or not, toward his special interest in nature and hunting. Many of his family members were active hunters who were also engaged in advocacy and who wrote about nature. Uncle Robert B. Roosevelt became a very strong voice for the protection of game fish in New York and eventually served as president of the New York Association for the Protection of Game. This organization was instrumental in the protection of wildlife in New York in the 1870s and 1880s. Uncle Robert also wrote and

published articles about game fish, most notably the tract titled "Game Fish of the Northern States of America and British Provinces," which was a very popular publication.

Elliott, Theodore's younger brother, went to Texas to hunt bison in 1877. Elliott, who was then just seventeen, and his cousin John Roosevelt were adventurous youth who went to the edge of the great Staked Plains in the panhandle of West Texas to hunt the last of the southern buffalo herd. They hunted for several months and relayed to young Theodore some great stories of hardship and adventure. These stories undoubtedly inspired Theodore to consider undertaking his own bison hunting adventure at some future time before bison were gone from this earth. Roosevelt shared the story of Elliott's great bison hunting adventures in Texas in his book *Wilderness Hunter* and clearly remarked about his brother's witness to the final destruction of the southern bison herd in 1877.

During his childhood, the United States reached a major milestone when it celebrated its 100th anniversary. The nation had clearly matured and evolved a more definitive form of governance and municipal rule. It had survived a civil war that redefined the principles of freedom and the relationship between states and federal government. As the country danced through Reconstruction, it seemed invincible and began exerting a significant role in the North American continent and around the world. From 1800 to 1900, the U.S. population began unprecedented growth, and the North American continent was to be forever changed. At the time of Roosevelt's birth, there were about ten people, and seventeen bison, per square mile in the United States. Within forty years, by the time of his election as vice president in 1900, there were about twenty-five people per square mile and bison were nearly extinct.

Perhaps as a consequence of his early family life, interest in nature and formal science education, Theodore Roosevelt developed a specific fascination with American bison. As he matured, this fascination only increased as he gained power and enthusiastically advanced his interests as a hunter-conservationist and naturalist. He intentionally traveled to North Dakota and Montana to hunt bison as a young man before the animal went extinct in the wild. Eventually, his conservation vision became centered on saving the American bison. He spoke and wrote often about bison in his books, lectures and messages to Congress. Even the White House décor was influenced by his fascination with the American bison. In 1908, he had the architects remove the African lion heads on the mantel of the State Dining Room in the White House and replaced them with American bison. He

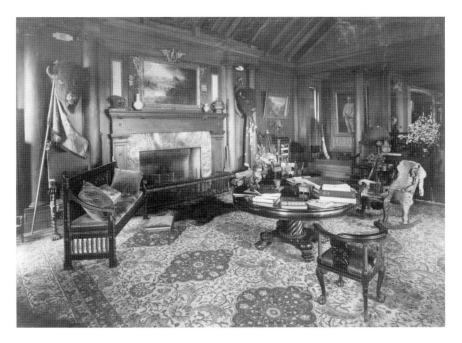

Trophy room at Sagamore Hill, summer home of Theodore Roosevelt, with bison heads over the mantel, 1910. *Library of Congress.*

said that the mounted bison heads made a "much more characteristic and American decoration."

Perhaps one of the most important scientific, and perhaps sociological, events of the nineteenth century was the publication of Darwin's *On the Origin of Species* in 1859. This came just one year after Roosevelt was born and spawned a long and intensive public discussion about the evolution of life, power of natural processes and the notion of functional ecosystems. Certainly Roosevelt was a Darwinian advocate, as is testified in his writing and thinking. In his book *Wilderness Warrior*, author Douglas Brinkley well describes how young Theodore formed his Darwinian views of mankind and how this influenced his relationship with nature. As Brinkley described in his thorough study of Roosevelt's life, young Theodore was a "natural theologist" and became an enthusiastic foot soldier in the Darwinian revolution.

Economic conditions and the quest for individual wealth during Theodore Roosevelt's time played a key role in the story of the destruction and subsequent conservation of American bison. There were multiple western rushes for precious metals (especially gold and silver) in western

mountain territories, an industrial revolution was underway in the East, entrepreneurial opportunity in the buffalo hide trade became possible for the brave and free land was opened for settlement by pioneers. These socioeconomic conditions drove a mass movement of people out of the East and into the West. Multitudes of individuals from eastern regions migrated to the West in what is now estimated by some to be the largest movement of humans in our history. More than 400,000 people moved from the East Coast into the West across mid-continent prairie landscapes in the 1840s. By the 1860s, as Roosevelt was a child, the fate of the Midwest and western landscapes was being determined, and the vision of Manifest Destiny was in full bloom across the entire American continent.

Forms of communication changed dramatically in North America as Roosevelt grew up. For thousands of years, the movement of human words and thoughts remained unchanged, as most ideas and messages were primarily carried by oral means. Although printing was invented in 1439 by Gutenberg and books were soon being printed and distributed worldwide, very few people actually could read, and industrial printing was centuries away. The limited mass production of printed material prevented widespread knowledge sharing. It seems inconceivable today, but in the United States, industrial printing, with a rotary printing press that could print hundreds of thousands of copies in a single day, was not introduced until 1843 by Richard M. Hoe, a mere fifteen years before Roosevelt was born. As a consequence, printed news about the great destruction of bison in the West was not widely shared until after industrial printing became possible and more people acquired reading skills. For many decades after the introduction of industrial printing, oral presentations and lectures in public forums remained the primary means of creating and informing any grass-roots movement, including nature conservation. The limited ability to widely share and read the newly emerging views from early naturalists and philosophers slowed the evolution of a public conscience for nature protection.

However, by the late 1870s, the printed media had become a major form of communication, and many magazines and books were being printed in the United States. Several new influential magazines were produced to advocate for conservation and influence readers about the bounty and plight of wildlife, including *American Sportsmen* (1871), *Forest and Stream* (1873), *Field and Stream* (1874) and the *American Angler* (1881). Both public oration and printed media were perfect mediums for great communicators such as Theodore Roosevelt, who knew how to use them and could harness his access to the

public and position of power to convey conservation messages. Wildlife and wildlands had finally gained a widespread voice in North America.

New communication technologies also increased the power of Roosevelt to reach out to the American public for the cause of conservation. The invention of a new means of quickly sending messages, the telegraph, and the eventual construction of a telegraph line system that crossed the country, along with the development of railroads and country road networks, enabled even greater messaging power to those of means. Suddenly it was possible for one individual to transmit information, or a new idea, from coast to coast. A powerful person like President Roosevelt could reach out to those he governed with his personal vision and extend his voice farther and wider than ever before. This new communication technology brought a means of rapid messaging that added a new capability to a young, enthusiastic, progressive communicator like Roosevelt, who had vision, money and power behind him.

Until the early 1800s, the capacity for humans to travel great distances across land had remained unchanged and depended on either foot or horsepower. There were many significant changes in transportation during the nineteenth century that coincided with, and perhaps partially facilitated, the great destruction of bison yet, at the very same time, helped conservation enthusiasts carry a new voice for nature protections across the nation. The late nineteenth century ushered in new means of mobilizing public outrage for the destruction of wildlife and wildlands in the United States.

Perhaps the most significant change that directly influenced Theodore Roosevelt's world and the future of bison was the extensive development of a nationwide railroad system. During the mid-nineteenth century, the invention of the steam locomotive and an extensive local rail system introduced a new form of travel for people and goods. The first commercial railway was commissioned in England in 1830, moving goods between Liverpool and Manchester. Development of an extensive rail system in the United States drove most of the human trade and increased the capacity for human movement across our country. The Transcontinental Railroad was completed in 1863–69 during Teddy's childhood and, at that time, was referred to as the Eighth Wonder of the World. In addition to moving people great distances, a modern rail system also made it possible to move trade goods, such as hides from slaughtered bison, out of the distant Great Plains to eastern tanneries. In 1869, when railroads were emerging as the primary means of long-distance travel, Teddy would have been a young boy, eleven years old, and well aware of the completion of the transcontinental railroad.

As he matured and grew into an influential man of his time, he routinely used railroads to travel west to engage in his ranching venture and extend his exploration of the natural world. He also used the railroad extensively to carry a conservation message across the country and share his enthusiasm for nature with people from distant parts of a vibrant developing country.

Roosevelt wrote about the importance of the railroad in the destruction of the American bison in his book *Wilderness Hunter*. In that book, he wrote that for bison, the "numbers decrease was very gradual until after the Civil War. They were not destroyed by the settlers, but by the railways and the skin hunters." He understood the link between the developing railroad system and near extinction of bison, stating that the railroad "supplied cheap and indispensable, but hitherto wholly lacking, means of transportation to the hunters; and at the same time the demand for robes and hides became very great."

Another technological development that had no immediate relationship to the destruction of bison but enabled the permanent conversion and occupation of the Great Plains habitat was the automobile. The automobile, with an internal combustion engine, was actually first put into production in Europe by 1886. The introduction of this machine to the United States was just around the corner when Theodore Roosevelt ventured to North Dakota to become a rancher and George Bird Grinnell penned his eulogy to bison. In America, the first automobile manufacture was in 1893, just after bison were nearly gone. By 1912, shortly after Roosevelt's failed second bid to become president, there were more than 1 million automobiles in the United States. Although automobiles—and their adjunct, farming machinery— cannot be specifically linked to the destruction of bison, they contributed to the increased mobility of Americans and the permanent conversion and settlement of bison habitats across the West. The appearance of automobiles and railroads greatly facilitated the movement of people to all areas of the United States and rapidly contributed to the massive conversion of the Great Plains to farmland, forever relegating bison to the remaining small intact grasslands that remain available today.

During Roosevelt's first term as president, the Wright brothers launched an entirely new mode of transportation with their early flights at Kitty Hawk in 1903. The prospect of people traveling even faster and moving more widely loomed across the skies of North America's Great Plains, hastening the notion that our continent was suddenly much smaller and that rapid human expansion was unstoppable, manifest and clearly imminent. Roosevelt was undoubtedly well aware of, and witness to, the

great changes in human capacity to move across this great land, and he understood the potential consequence of increased human mobility to rapidly destroy wildlife and diminish wildlands without restraining policies and mechanisms imposed by a responsible government. He grew up and gained his own political power during a time of great change that would permanently alter the relationship between man and nature. Rapidly emerging technologies, modern means of transportation and transformational social change certainly brought a sense of urgency to the cause of saving remnant wild landscapes and preserving dwindling wildlife populations by the early twentieth century.

THE HEART AND MIND
OF THEODORE ROOSEVELT

Theodore Roosevelt's wealth and personal experiences enabled him to see and understand the world beyond his home in New York and learn about human history while traveling around the globe with his family. This travel around the world and experiences in distant lands heightened his awareness of nature and its diversity. Unlike most people from that time, he experienced and absorbed the diversity of nature during youthful travels to Europe, Middle East and Africa. He personally engaged with varied groups of people during his travels and observed the wide diversity of nature in these distant lands, intensifying his growing interest in nature and wild places. This vast experience with many peoples in many lands enhanced his capacity to recognize the human need to conserve nature.

As a result of his family environment, his formal education and worldwide experiences, Roosevelt acquired an ability to perceive the world across big geographies and long-term scales. Whether he knew it or not, at an early age he was beginning to practice Seven Generations Thinking. At that time, few people in North America were thinking about large time scales around the world they lived in. Roosevelt's privilege, progressive thinking and powerful position in society allowed him to think and see into the future more clearly than most, and it caused him to fear the impending loss of wild nature. This concern is evidenced by his writings and actions, where he laments the destruction of wildlands and wildlife such as the American bison when, at that time, most people could not or would not consider this a great loss and might actually consider it a preordained destiny.

Roosevelt took on a certain warrior mentality as he served as soldier, social activist and political figure in America. This fierce warrior mentality probably began with the frequent physical rivalry expressed during his youth as a boxer and his lifelong advocacy of the strenuous life to overcome his infirmities as a boy. This warrior attitude naturally extended to his leadership role while serving as a colonel in the military and after he assumed the mantle of public service. In all of these formational processes, he was gradually being prepared for the pending political combat that would come with his reformist social views and vision of a world that conserved nature and restored species to their rightful place. The importance of his warrior mentality cannot be underestimated in terms of his eventual success as the champion for the conservation of bison and other wildlife. He developed a very keen understanding of nature and man's role in it, whether good or bad. He began to understand and witness that nature had limits and humans were inclined to exploit nature beyond those limits, reducing its capacity to serve mankind. He developed a personal indignation about the influence of man's actions and self-serving decisions that led to the destruction of the natural world for personal gain and wealth.

As a college-educated man and throughout his life, Roosevelt was regularly exposed to writings of the philosophers, artists and naturalists of the times, such as Henry David Thoreau, Ralph Waldo Emerson, John Burroughs, George Catlin, Frederic Remington and John James Audubon, who articulated a whole new view of nature through thought, language and visual arts. He also became well acquainted with the conservation-minded activists from his time like William Hornaday, John Muir and George Bird Grinnell. However, although these men advocated a progressive worldview, none of these influential people could effectively harness the power of the people and government through a prominent political position like that acquired by Theodore Roosevelt. It was primarily through his powerful social position, personal energy and political artistry that he influenced many in his power sphere and enlisted the help of others to carry a new voice for conservation to the American public, policy makers and those in governance.

Roosevelt not only read the works of progressive thinkers but also actually sought out, and was influenced greatly by, several nature philosophers and writers of that time. He met John Burroughs in 1889 at a Fellowcraft Club dinner, where he shared his enthusiasm for Burroughs's books *Birds and Poets* and *Locusts and Honey*. He mentioned how these writings made him homesick and how truly "American" they were. Roosevelt was known to recommend Burroughs's writing to others and believed that Burroughs focused on "all

that was good and important in life." In the spring of 1903, John Burroughs traveled widely with Roosevelt, and they camped in Yellowstone National Park to spend time seeing wildlife in the nation's first national park. Later in 1903, Roosevelt dedicated his book *Outdoor Pastimes of an American Hunter* to Burroughs. The influence of John Muir is also well described in the historical records from the twentieth century. Roosevelt communicated routinely with Muir by mail and eventually met him during a trip to Yosemite in 1903. They tramped through the backcountry for three days and two nights. During these travels, they shared conversations around campfires about their respective Wild West adventures.

One of the earliest voices for bison conservation that moved Roosevelt toward a vision of conservation and restoration of wildlife was that of George Catlin, an artist who painted the frontier that Roosevelt soon came to love. His paintings immortalized the great buffalo hunts and the thrill of the chase in its purest traditional form and custom. As one of the earliest voices for bison conservation, his words bemoaned the loss of American bison. He was perhaps one of the first advocates for large landscapes where they could be saved. As Catlin noted in 1832:

> *It's a melancholy contemplation for one who has traveled as I have through these realms and have seen this noble animal (the buffalo) in all its pride and glory, to contemplate it so rapidly wasting from the world, drawing the irresistible conclusion too, which one must do, that its species is soon to be extinguished, and with it the peace and happiness (if not the actual existence) of the tribes of Indians who are joint tenants with them, in the occupancy of these vast and idle plains....And what a splendid contemplation too, when one (who has travelled these realms and can duly appreciate them) imagines them as they might in future be seen (by some great protecting policy of government) preserved in their pristine beauty and wildness a magnificent park, where the world could see for ages to come, the native Indian in his classic attire, galloping his wild horse, with sinewy bow, and shield and lance, amid the fleeting herds of elks and buffaloes. What a beautiful and thrilling specimen for America to preserve and hold up to the view of her refined citizens and the world in future ages! A nation's Park containing man and beast, in all the wild and freshness of their nature's beauty.*

Roosevelt's relationship with nature was very personal, and that relationship led to his willingness to engineer policy to preserve nature.

Consistent with his views of nature was the notion that it was something to be experienced, not just observed from afar. Roosevelt genuinely engaged nature through his personal exploration and hunting expeditions. He also pursued nature as a healing environment and often fled to wild country when experiencing tragedy and conflict. He escaped to the Dakotas after his difficult time facing the death of his wife and then his mother. We see Roosevelt taking an African hunting trip after his last term in office. Finally, he took his expedition to the River of Doubt when he narrowly lost his bid for president as a Bull Moose candidate.

To Roosevelt, the American bison was a symbol of a wild nature and western culture that he dearly loved. As he gained knowledge, he grew to greatly respect this animal and became so concerned that it might disappear that he determined to go hunting in the Dakotas before it disappeared. He hunted and killed his first buffalo in 1883, at the age of twenty-four, in Montana at Little Cannonball Creek. This story is prominently told and retold in many books and forms one of the earliest direct connections between the iconic power of the American bison and Theodore Roosevelt. Up until that first hunt, bison were likely an abstract and romantic symbol of the vanishing West to Roosevelt. Later, on his second bison hunt in 1889, we see that Roosevelt became more sanguine about the destruction of this species. After his second hunt, he reflected on these beasts:

> So for several minutes I watched the great beasts as they grazed.....mixed with the eager excitement of the hunter was a certain half-melancholy feeling as I gazed on these bison, themselves part of the last remnant of a doomed and nearly vanished race. Few indeed are the men who now have or evermore shall have, the chance of seeing the mightiest of American beasts, in all his wild vigor, surrounded by the tremendous desolation of his far-off mountain home.

After these hunting expeditions, he began to see returning bison to lands in the West as an important expression of human good will, and he determined to do the right thing and correct the wrongful destruction of bison by mankind. Roosevelt may have emerged as the patriarch of the modern conservation movement because of his own youthful quest to hunt the largest land mammal on the continent.

Roosevelt was also an ardent bird watcher and fancied himself a skilled ornithologist. As a very young naturalist, he was collecting and stuffing bird specimens for his home museum. All throughout his life, he recounted

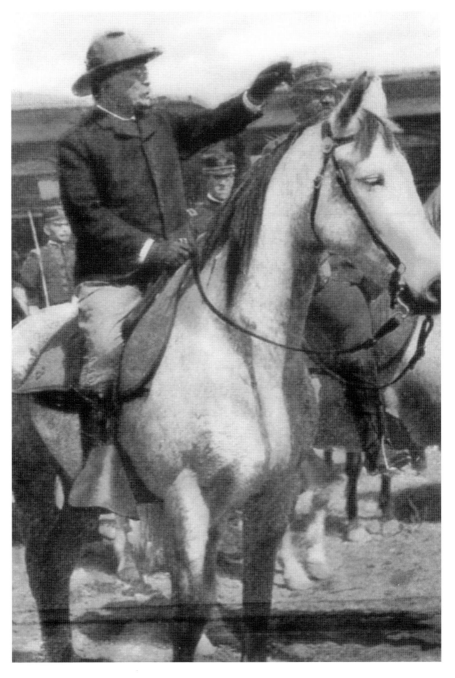

President Roosevelt in Cinnabar, Montana near Yellowstone National Park, 1903, photographer unknown.

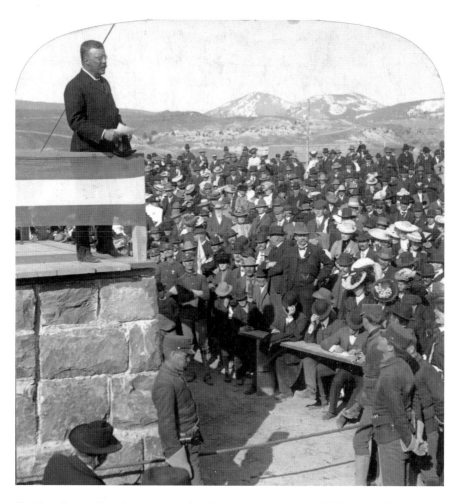

President Roosevelt addresses a crowd at the new entrance gate to Yellowstone National Park, now referred to as the Roosevelt Arch, July 28, 1903. *Underwood and Underwood, Library of Congress.*

support for the conservation of America's birds in public dialogues and helped launch the Audubon Society. Just before his presidency, he wrote to Frank Chapman, stating, "I need hardly to say how heartily I sympathize with the purposes of the Audubon Society." It may have been his love for birds that first led to his conservation views and the protection of species. In his letters to Chapman, he stated it most clearly: "I would like to see all harmless wild things, but especially all birds, protected in every way. I do not understand how any man or woman who really loves nature can fail to try to exert influence in support of such objects as those of the Audubon

Society." Today, these nongovernmental organizations remain essential to the mission of protecting wildlife and wild places.

Roosevelt's zeal to save wildlife and wildlands was consistent with his advocacy of the "strenuous life" and his warrior approach, once convicted by an honorable cause. Restoring nature was a new idea and very hard, even in the early 1900s. Specifically, the quest to save American bison put him squarely in conflict with some of the western states that had pursued a different course for the western lands. The *Kansas City Journal* published a harsh editorial, calling William Hornaday and the American Bison Society self-important buffoons for pursuing the purchase and restoration of bison and arguing that few Americans supported such an idea. We can be certain that, at this time, few people considered that the protection of nature, and a big woolly animal like bison, should weigh against the obvious imminent destiny of a great nation. The mindset of most people was simply that nature was for the taking, and for the country to become great, nature must be exploited and utilized to develop a civilized nation. For many, seeking to help save wildlife and protect wildlands was just un-American. It is unlikely we can fully appreciate the negative reactions these progressives and eastern dandies received when they proposed to save wildlife and wildlands in the great American West, but that did not deter them.

SAVING THE AMERICAN BISON

Although Theodore Roosevelt was a nature enthusiast from his youth, his ascension to power culminated in genuine authority as president of the United States to advance his specific conservation agenda. Roosevelt's rise to political power was by a steady and determined movement through various positions and steps. He began within the New York Assembly in 1881 and had gained the presidency by 1901. His roles as New York police commissioner (1895), navy secretary (1897), colonel in the U.S. Army (1898), governor of New York (1898), U.S. Civil Service commissioner (1889) and vice president (1900) prepared him for political battles of any sort. During his public service, he steadily honed his political abilities and built a substantial network of contacts among the power elite of the United States. His progression to the presidency by 1901 empowered him effectively to shape public policy through sheer determination, powerful oratory and a strong sense of public service commitment. Roosevelt finally

could act as a nature policy advocate from the most powerful position in the nation, perhaps the world.

A big part of Roosevelt's success, as the conservation president and savior of American bison, was his extensive social network with other like-minded politicians and professionals. He was an expert in building the right relationships at the right time to mobilize his conservation army to a specific cause or action. These "Roosevelt men" (and some women) began advancing conservation of wildlands and wildlife without much of the knowledge and experience we enjoy today. They applied the best methods and scientific understanding that were available to them at that time to accomplish the mission. The focus was primarily in saving species (at least living representation at zoos and refuges), connecting youth to nature, creating new conservation laws and bringing about changes in land use to preserve nature for all to enjoy.

Most of Roosevelt's early public service career was not directly focused on natural resource issues, but his personal life and interest kept him involved in many new emerging civic organizations for nature conservation. Once Roosevelt gained political influence and power, he and his acquaintances molded a full suite of conservation organizations and land conservation programs to advance a new vision for wildlife and wildland conservation. During his early political years, Roosevelt and his naturalist zeal operated in somewhat parallel universes. He eventually found the intersection between his political power and love of nature when he became the twenty-sixth U.S. president and could make significant decisions to save bison and preserve nature. With the power of the presidency, Theodore could really make significant changes in land use and formed a system of Wildlife Refuge and Forest Reserves. Each organization and emerging land protections he helped form served a unique mission and purpose, but collectively they complemented one another to create an entire natural resource coalition that melded into the modern conservation movement we know today. The development of these organizations and government programs was central to the recovery and restoration of the American bison. Without these people and new policies in place, bison would have had no institutional support, or homeland, on which to make a comeback.

The notion of a national park was not a new idea at the time Theodore Roosevelt assumed the mantle of power in Washington, D.C. A park for the entire nation was discussed by several of the early conservationists and progressives, as well as railroad tycoons and politicians seeking economic development. The concept of a place for all people was born out of the

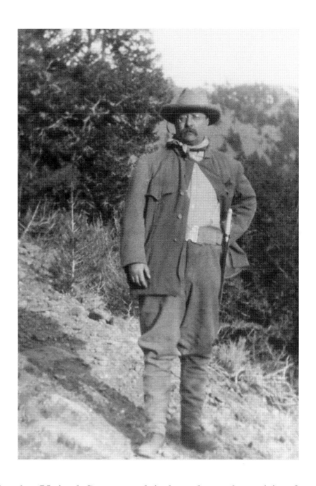

President Roosevelt during his trip to Yellowstone National Park in 1903, photographer unknown.

Romantic movement in the United States and is based on the spirit of equality from the American Revolution. This idea became a nascent reality when the first national park, Yellowstone National Park, was signed into law and existence in 1872 by Ulysses S. Grant. The National Park System was coded in law in 1916 and now includes more than four hundred units across all fifty states.

Young Teddy Roosevelt would have been at the impressionable age of just fourteen years when Yellowstone National Park was first created. He would eventually visit that site and build on the dreams of others who envisioned saving nature at wondrous national parks sprinkled across the country. Bison became a prominent conservation goal at several new parks, and there was the opportunity to use these parks to restore bison before they disappeared forever. Roosevelt had a significant impact or inspired the restoration of bison in Yellowstone National Park, Wind Cave National Park and certainly

Theodore Roosevelt National Park. Today, Theodore Roosevelt National Park includes one (the Elkhorn Ranch) of two ranches Roosevelt purchased and managed in North Dakota in the late 1800s. Today, there are ten national parks that provide habitat for about ten thousand American bison.

Although many people believe that Roosevelt created the first national forest, in fact, the first forest reserve was established by Congress on October 1, 1890, in the Sierra Nevada Mountains. The Forest Reserve Act of 1891 established the power to create National Forest Reserves, and President Benjamin Harris established a forest reserve near Yellowstone National Park that became the Shoshone National Forest. President Grover Cleveland then established 26 million acres of forest reserves, and William McKinley created an additional 7 million acres of national forests while he was president. The truly amazing record holder, though, was certainly Theodore Roosevelt, who designated more than 150 million acres as forest reserves, as he established the National Forest Service, led by Gifford Pinchot. Gifford Pinchot was a strong ally of Roosevelt's and also a member of the American Bison Society. Although these national forest reserves were not originally established to

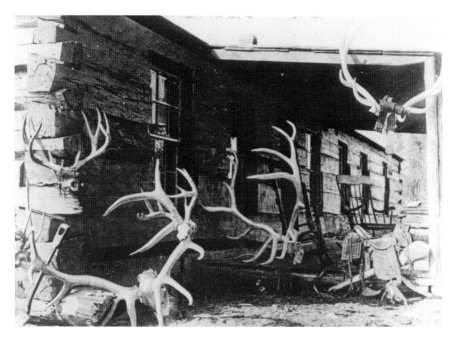

The veranda of Theodore Roosevelt's Elkhorn Ranch on the Little Missouri River in North Dakota. Today, it is part of Theodore Roosevelt National Park. *National Park Service photograph.*

help restore bison, they play a role in many locations where bison exist today, including regions near Yellowstone National Park and Grand Canyon National Park and on multiple National Grasslands, which are administered by the U.S. Forest Service. Today, there are bison roaming on Forest Service lands at the Midewin Prairie Preserve, Buffalo Gap National Grasslands near Badlands National Park, the Gallatin National Forest near Yellowstone National Park and the Kaibab National Forest adjacent to Grand Canyon National Park.

Whereas Roosevelt did not create the first national park or forest, he did create the first national wildlife refuge, Pelican Island National Wildlife Refuge, by executive order in 1903. In the remaining six years he was in office, Roosevelt established fifty more refuges and established an entire National Wildlife Refuge System. Roosevelt's relationship to national refuges creates a major connection to his efforts to restore American bison. Several bison habitats established by the American Bison Society with the help of Roosevelt, such as Wichita Mountains Wildlife Refuge and National Bison Range, became prominent refuges for the American bison. What is also important to recognize about the bison reintroduction to the Wichita Mountains is that it represents the first animal restoration project in our national history. The bison for this reintroduction came from private sources via the New York Bronx Zoo, so it may also represent one of the first private-public partnerships to restore wildlife. These incredible firsts in conservation should not be taken lightly and represented significant milestones in our country's environmental history. Efforts to restore bison on national wildlife refuges have continued for the past one hundred years, and there are now about 1,400 bison hosted on six national wildlife refuges in six states.

The Antiquities Act was passed in 1906 and established the means for protecting national treasures through a simple presidential proclamation. President Theodore Roosevelt established the first national monument at Devils Tower National Monument in September 1906. During his presidency, he established 18 national monuments, although only 9 of these exist in that status today. Today, there are 125 national monuments, and just 2 that support bison herds. Twenty-three monument sites are associated with American Indian culture and preserve lands sacred to Indian people. Most notable of Roosevelt's monuments was Grand Canyon National Monument (1908), which eventually became Grand Canyon National Park (1919). Here, a wild bison herd of five hundred to seven hundred still ranges freely across several hundred thousand acres of U.S. Forest Service, National Park Service and Arizona jurisdictions.

Roosevelt worked to conserve many wildlife species and personally considered this noble work. He knew how to organize people and helped create many new nongovernmental organizations to advance conservation. The Boone and Crockett Club was founded in 1887 by Roosevelt and several other prominent conservationists, such as George Bird Grinnell and Archibald Rogers. Roosevelt became its first president while serving in the New York Assembly. It was through this role as president of the Boone and Crockett Club that he met and began to associate with many of the men whom he would later recruit for his crusade to save wildlife. Ironically, this new club included General Philip Sheridan and General William Tecumseh Sherman, who previously implemented the harsh military policy against American bison. While serving as the first Boone and Crockett Club president, Roosevelt also met William Hornaday and teamed up with Gifford Pinchot. The Boone and Crockett Club provided an important vehicle to recruit many, and varied, conservation champions to begin the campaign to save the last remaining wild places with remnant wildlife populations.

The first calls to save the American bison actually date back to the 1830s, when George Catlin was documenting the American West in his paintings and drawings. The call to save bison was repeated not long afterward by John James Audubon, who compared the predicament of bison he observed in 1843 with that of the extinct great auk. In the late 1800s, there were several failed legislative attempts to consider the plight of the American bison, but none succeeded in practice. In 1874, a bill to protect bison made it through Congress but was never signed by President Grant. Several states—including Montana, Idaho and Nebraska—attempted to protect bison, but these state efforts had no real enforcement capacity. In Canada, the first Council of the Northwest Territories also passed an ordinance to protect bison, but it was repealed in 1878. Even in the newly formed Yellowstone National Park, poaching of bison continued through the 1890s despite the presence of the United States Army, which was appointed to protect this large natural landscape and its wildlife. The bottom line is that these early attempts to rescue bison were not successful because there was not yet widespread public support and very limited political will to stem the loss of the American bison.

By 1889, at age thirty-one, Theodore Roosevelt had an epiphany that forever changed his relationship to the American bison and forged his earnest commitment to saving wildlife and wildlands. As he bore personal witness to what seemed the final days of the American bison, as well as other big game ranging across the great American West, he was moved to take action for their recovery before it was too late. By the end of his term as president

Bison grazing at the New York Zoological Park in about 1900. *Library of Congress.*

of the United States, the American bison had been successfully restored to several landscapes and numbered over three thousand. The species was being methodically pulled back from the brink of extinction. In his autobiography, Roosevelt enumerated the many acts to preserve bison as highlights of his term as president of the United States. Helping to save the last bison in Yellowstone National Park, creating the Wichita Mountains Wildlife Refuge for a home to wild bison and establishing the National Bison Range are listed among his favorite accomplishments. Given his bison hunting episodes and personal ties to the valiant efforts to restore bison in North America, it is honest to say that Roosevelt became the American president who did the most to save the American bison.

AN UNEASY RELATIONSHIP
WITH BUFFALO PEOPLE

One of the most prominent events in the history of the American West that coincides with Theodore Roosevelt's childhood and youth were the major Indian wars in the West from 1850 to 1890. Significant Indian conflict transpired during his youth, and leaders of these native uprisings were often

in the news. Most of these news reports portrayed Indians as savage and cruel as they confronted the growing invasion of Euro-American settlers. In 1875, Quanah Parker and the last of the Quahadi Comanches surrendered. Following the destruction of Custer and his forces at the Little Bighorn in 1876, Sitting Bull escaped into Canada and did not return until 1881. In 1877, Chief Joseph was captured after his dramatic chase across Montana. In 1886, Geronimo and his people were captured and removed onto their reservation for good. Also in 1886, the Ghost Dance was invoked despite the federal "Code of Religious Offenses of 1883" forbidding such certain ceremonies. A new Indian leader named Wovoka prophesized the return of bison and inspired new hope to the demoralized tribes of the Great Plains, culminating in the massacre at Wounded Knee in South Dakota on the Pine Ridge Reservation in 1890.

All of these dramatic events undoubtedly came to the attention of a young Roosevelt, as he grew up into a political force in the United States. Young Teddy would have heard about the final days of the great American Indian wars and certainly knew about the capture and subjugation of the Indians of the American West. What kind of impact these events and stories had on young Theodore is not clear, but his relationship with Native Americans is filled with some conflict and raises some interesting questions. We do not know if young Roosevelt linked the destruction of bison to the subjugation of the Indian.

Theodore shared limited information about his understanding and experience with the Native American condition until he became involved with his adventures in North Dakota when he wrote *Hunting Trips of a Ranchman and Wilderness Hunter* in 1885 and *Winning of the West*, which was published in 1894. From these writings and a few public lectures, we get a picture of Roosevelt's views of the subjugation of the American Indian. As an advocate of the Darwinian revolution, he held a Darwinian view regarding Native Americans. He felt that they must adapt to the dominant culture emerging in North America—the dominant white race and civilized man was the best future for America. He did not see the loss of native cultures as a significant event needing his political intervention and did not champion their cultural preservation. It seems, by omission, that he did not draw a strong connection between the loss of the American bison and the collapse of Native American cultures.

Roosevelt presents a somewhat conflicted relationship with the original people groups of the Americas. On one hand, he was a clear proponent for full assimilation of the native people as the best way to enable them

A group of Native Americans visit the Bronx Zoo in New York in about 1913. *Wildlife Conservation Society Library and Archives.*

to survive. On the other hand, he admired their innate abilities, strengths and evident closeness to nature. His personal relationships with Native Americans reflected his conflicted nature. He did espouse a belief in the basic capacity of the American Indian to assimilate, and this was his primary doctrine in his treatment of them. At a speech in Franklin, Oklahoma, in 1905, he shared his views on equality for the American Indian. Roosevelt sat on the stage with Quanah Parker of the Comanches and stated, "Give the red man the same chance as the white. This country is founded on a doctrine of giving each man a fair show to see what there is in him."

He viewed Quanah Parker's success as a farmer and rancher as testimony to this fact. Roosevelt was pretty clear in his message of Manifest Destiny and the conquest of the continent by Euro-Americans. He did not consider that the American Indian was owed any special treatment in the progressive agenda he championed.

In *The Winning of the West*, Roosevelt wrote, "Nowadays we undoubtedly ought to break up the great Indian reservations, disregard the tribal

governments, allot the land in severalty (with, however, only a limited power of alienation), and treat the Indians as we do other citizens, with certain exceptions, for their sakes as well as ours."

In some cases, his language about American Indians seems harsh and troubling in the context of the contemporary movement for acceptance and tolerance for cultural diversity. Roosevelt delivered a telling Lowell Institute lecture in Boston, Massachusetts, in 1892 at which he defended the government's treatment of Indians: "This continent had to be won. We need not waste our time in dealing with any sentimentalist who believes that, on account of any abstract principle, it would have been right to leave this continent to the domain, the hunting ground of squalid savages. It had to be taken by the white race."

With regard to Indians, in 1901 President Roosevelt stated, "In my judgment the time has arrived when we should definitely make up our minds to recognize the Indian as an individual and not as a member of a tribe. The General Allotment Act is a mighty pulverizing engine to break up the tribal mass."

Roosevelt's writings in *The Winning of the West* further explore a brutal perspective of the Indian subjugation through war and treaty, and he probably articulated attitudes of the dominant race of people during the early stages of our country's growth and development. Roosevelt wrote that there was a necessity and even righteousness to battle with the Indian nations in North America: "Whether the whites won the land by treaty, by armed conquest, or, as was actually the case, by a mixture of both, mattered comparatively little so long as the land was won. It was all important that it should be won for the benefit of civilization and in the interests of mankind." A somewhat more brutal statement in that same book notes, "The most ultimately righteous of all war is the war with savages, although it is apt to be the most terrible and inhuman. The rude fierce settler who drives the savage from the land lays all civilized mankind under a debt to him."

Roosevelt felt that Indian wars were inevitable and that treaties and dialogue were not a solution to the problems between these two worlds. Regarding treaties, he wrote, "No treaty could be satisfactory to the whites, no treaty served the needs of humanity and civilization, unless it gave the land to the Americans as unreservedly as any successful war. As a matter of fact the lands we have won from the Indians have been as much by treaty as by war; but it was almost always war, or else the menace and possibility of war that secured the treaty."

His lands policy reflected his beliefs that tribes were not the rightful owners of lands they occupied. Two important aspects of his lands policy are critical to understanding his relationship to Native Americans as legitimate owners of lands in the United States. Generally, he did not see a path forward for native people through the reservation process, and he focused his lands policy on assimilation. When several tribal leaders, including Quanah Parker and Geronimo, pleaded for return to homelands, he denied them. In *The Winning of the West*, he wrote, "The truth is, the Indians never had any real title to the soil."

He compared Indian rights to the land with those of cattle ranchers trying to keep immigrants off their vast, unfenced ranges. Although his land policy seemed to protect natural landscapes across the country, it was not for the sake of restoring native cultures and the ancient buffalo lifeways.

As far back as 1778, many land claims by American Indians were incrementally diminished through a series of 372 treaties negotiated nation to nation. After 1871, the U.S. government no longer negotiated treaties for land cessions, and most lands were taken by executive order. Congress felt that treaties were a failed instrument and enabled the tribes to continue some measure of self-government. During the period from 1871 to 1890, there were tremendous efforts to further reduce the landholdings of American Indians in the West, increasing their dependency and making more land available to white settlers. Desperate to find a way to sustain basic life needs, many tribes had no alternative but to consent. President Roosevelt himself issued eight proclamations that transferred 15 million acres of Indian timber on reservations created by executive order to adjacent national forests. The reservations included Fort Apache, Mescalero, Jicarilla, San Carlos, Zuni, Hoopa Valley, Tule River and Navajo. The proclamation regarding the enlargement of the Trinity National Forest to include most of the Hoopa Reservation stated that after twenty-five years, any un-allotted land on the reservation was to become a part of the national forest, and the Hoopas were to lose their rights to this land.

Although Roosevelt was not supportive of restoring buffalo lifeways among the Indian nations, he did show some enthusiasm for assimilating Native Americans into modern society. He featured American Indians in his ceremonies and even in his administration. In 1891, four groups of Indian Service employees—physicians, school superintendents and assistant superintendents, schoolteachers and matrons—were placed under Civil Service classifications. As a member of the Civil Service Commission,

Theodore Roosevelt advocated that Civil Service rules be modified so that Indians could be given preference for these positions.

As a sitting president, he did meet with tribal leaders several times. President Roosevelt visited Frederick, Oklahoma Territory, in April 1905, where he was met by an honor guard that included Comanche leader Quanah Parker. Roosevelt asked Parker to join him on the speakers' stand as he addressed the people of Oklahoma, who were seeking statehood. President Roosevelt asked the Indian Service to provide "a touch of color" for his inaugural parade by providing some Indians. The Indian Service provided Geronimo (Apache), Quanah Parker (Comanche), American Horse (Sioux), Hollow Horn Bear (Sioux), Little Plume (Blackfoot) and Buckskin Charley (Ute). These Indian leaders, called "chiefs" by the press, rode painted ponies and led a troop of marching Carlisle Indian students up Pennsylvania Avenue. Along the parade route, the Indians were met with war whoops and similar derisive shouts from the crowd.

Several Indian chiefs, including Geronimo and Quanah Parker, lead the inaugural parade of President Roosevelt in Washington, D.C., 1905. *Benjamin Boyd Singley, Library of Congress.*

Roosevelt showed great sympathy for the loss of the American bison in the West but demonstrated little compassion for the declining culture of native people, who had shared the world with these same buffalo. It seems that he did not clearly associate the need for conservation of this species with preserving the ancient cultural relationships between American Indians and bison. The government policy of assimilation, discouragement of cultural practices and repeated land cessions reduced the American Indian to a status of dependency and did not encourage a vision for the return to buffalo ways. As a result of this prevailing view in the United States, tribal leaders and native communities were no longer able to reconnect to nature in any way that resembled their traditional lifeways. It seemed that the American bison could no longer be at the center of their spiritual, cultural or economic world. Unfortunately, it was not until the 1960s that American Indians began to restore bison to tribal lands and only recently (1992) when the Intertribal Buffalo Council was formed and chartered by the federal government to accomplish the mission of restoring bison to Indian lands. Despite clear knowledge of the close cultural and spiritual relationship between native people of the plains and the American bison, there was an inexplicable gap of sixty years between early bison recovery efforts and full tribal engagement in bison restoration.

THE NORTHERN BUFFALO TREATY

The tribes and First Nations in Canada and the United States own and manage a vast amount of intact grassland habitat (about 6 million acres) across the Great Plains and Intermountain West. These intact grasslands provide suitable habitat for American bison if they remain in their natural state. Native peoples of the Great Plains are culturally disposed to protecting their homelands, connecting spiritually and physically with free roaming buffalo, and express considerable interest in bison repatriation to native landscapes. Although individually each tribe has limited resources and political influence to achieve the grand vision of bison restoration, it is feasible that the combined voice of indigenous people and clearly expressed political unity could achieve bison ecological restoration and renewal of native cultures.

In response to this notion, during the summer of 2014, Blackfeet emissaries, along with representatives from the Wildlife Conservation Society,

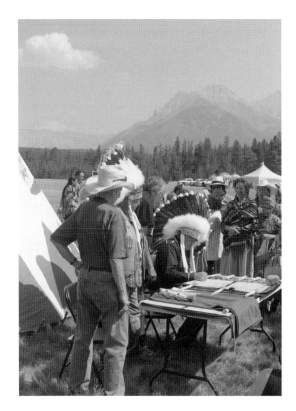

Samson Cree and Stoney tribes sign the Buffalo Treaty at Banff, Alberta, in August 2015. *Photo by Keith Aune.*

visited Tribal Councils at the Confederated Salish and Kootenai, Fort Peck, Tsu T'ina, Piikani, Kainai and Fort Belknap Reservations to advocate for an intertribal treaty, calling for the return of buffalo and conservation of tribal lands. On June 25 and 26, 2014, the Blackfeet Nation and Wildlife Conservation Society hosted a treaty planning meeting with representatives from eleven different tribal bands, including Salish, Kootenai, Kainai, Piikanni, Siksika, Amskapi-Pikuni, Assiniboine, Gros-Ventre, Sioux, Nakoda and Tsu T'ina. These tribal bands sent representatives from eight tribal governments to sign a buffalo treaty that emphasized renewal, cooperation and restoration.

This Northern Buffalo Treaty Convention was hosted on September 23, 2014, and the historic treaty was signed within a traditional encampment on the Blackfeet Buffalo Pasture near Browning, Montana. These tribal representatives approved the articles to the treaty and carried them back to their respective councils for further review and ratification. This may have been the first intertribal treaty among these tribes in more than 150 years. The event received international media coverage, with at least 240 stories

presented around the world, including in Japan, Germany, Russia, France, Spain, Slovakia and the United Kingdom. The Buffalo Treaty formed tribal alliances for cooperation on conservation of bison, cultural enrichment, youth education, research and economic development. The Buffalo Treaty was also signed by more than fifty witnesses (nongovernment organizations, government representatives and tribal members at large) to indicate their support and partnership in these endeavors.

Since that original signing, three additional meetings have been held; in August 2015 at Banff, Alberta; in September 2015 at the Fort Peck Reservation; and in September 2016, again in Banff. As a result of these additional meetings and discussions, the number of signatories to the treaty has been expanded to include the Stoney Nakoda Nation and Samson Cree from Alberta and nine First Nations (mostly Cree) from Treaty 4 in Saskatchewan, Canada. This unique buffalo treaty brings the united voice of these tribes/First Nations to respective federal, state and provincial governments and ensures intertribal unity and cooperation to help achieve the restoration of the American bison. Further work by these tribes and First Nations is anticipated, and additional tribes and First Nations are interested in joining the venture at the next treaty convention, planned at the Confederated Salish and Kootenai Reservation in Montana.

LEGACY BISON: DR. WILLIAM HORNADAY'S GREAT BULL

In 1890, a very famous taxidermy display of a bison family was opened at the Smithsonian Museum of Natural History (now displayed at the Museum of the Northern Great Plains in Fort Benton, Montana). This diorama featured an entire family group mounted by the naturalist Dr. William Hornaday, following a legendary hunt for the last wild bison in central Montana during the spring and fall of 1886. This expedition, led by Dr. Hornaday, was an effort to immortalize rapidly disappearing wild bison before they went extinct in North America. In his own words, Hornaday explained, "Perhaps you think a wild animal has no soul; but let me tell you it has. Its skin is its soul and when mounted by skillful hands, it becomes comparatively immortal." This display was Hornaday's way of presenting these wild animals to the public because he believed they would disappear in a few short years. He hoped that an awe-inspiring display of a vanishing species might have a great

The Great Bull from the Hornaday display, currently at the Agriculture Museum in Fort Benton, Montana. *Photograph by Keith Aune.*

effect in raising public awareness of the decimation of wild bison and the need for dramatic conservation action to preserve those few that remained.

One of the legacy animals in this display is the old stub-horned bull that Hornaday collected at the very end of his expedition into Montana. The fall expedition in 1886 was a trip filled with adventure and excitement, but also sadness and remorse for the status of bison. In all, the expedition collected twenty-five bison from a presumed herd of thirty-five, leaving even fewer to survive the next winter. At that time, bison may have only existed in three or four areas outside Yellowstone National Park and Wood Buffalo National Park in Canada. However, some evidence for any bison at most of these potential sites was wanting. After careful review, Dr. Hornaday chose to go to Montana despite some warnings that there were no bison left in this remote habitat.

This last great bison hunt to collect museum specimens was located in a very remote area of central Montana that today still looks very much like it did in 1886. The night sky here is filled with bright stars because there is not one artificial lamp on the horizon. This final Hornaday camp, one of three such camps, occupied the late fall of 1886 and was situated near the Buffalo Buttes, which is today designated a Montana Historic Site. It was

The historic map of bison distribution created by Dr. William Hornaday in 1889. *Wildlife Conservation Society Library and Archives.*

near this camp that on December 6, 1886, William Hornaday took one last hunt before his return to Miles City, Montana, on December 13.

During the crowning episode of this last great buffalo hunt, William Hornaday and Jim McNamey stumbled upon a magnificent specimen, the biggest bison bull Hornaday had collected to date. He shot and, after a considerable chase, killed this eleven-year-old wild stub-horned bull that had lived in the Buffalo Buttes area as one of the last wild bison in North America. When he skinned the huge animal to prepare it for taxidermy, four different bullets were extracted. One was located very near the lumbar vertebrae, yet the animal was agile and mobile until its final breath. Hornaday shared a graphic and quite dramatic description of its final breath in an article for *Cosmopolitan* in 1887.

This old bull in the Hornaday display was clearly a legacy bison that represented his species very well and had faced a very difficult period for

the American bison with resilience and endurance. In the coming years, the great bull in this display would find a degree of immortality, just as Hornaday intended, within the museum walls and beyond. Some say that he was featured on several commemorative stamps issued from 1923 to 1976 and was used as the model for the National Park Service ranger badge and the Department of the Interior official seal. However, the real quest for bison immortality remains for us to consider yet today through the ecological restoration of this historic symbol of American wildness.

AWAKENING

One of the game-changing conservation measures of the nineteenth century was the establishment of Yellowstone National Park in 1872. The notion of establishing a public park around the natural features of Yellowstone actually evolved over time. Famous expeditions of Yellowstone by General Henry Washburn in 1870 and Dr. Ferdinand Hayden in 1871 established the credibility of wondrous claims about geologic features found there and raised public awareness of the unique character of Yellowstone. Soon everyone was talking about this region and marveling at its geologic wonders and wildlife. The stories carried throughout the country and even in Washington, D.C., circles. The establishment of Yellowstone National Park, through an act of Congress, was finally articulated by Judge William D. Kelley in a letter to Dr. Hayden that introduced the "national park idea" that is highly celebrated today. Dr. Hayden immediately put forth this very vision in his final report from the expedition. It was not long until the first national park, Yellowstone National Park, was established when Ulysses S. Grant signed the bill into law on March 1, 1872. Although geologic wonders of the area were prominent drivers in the establishment of Yellowstone National Park, it also became the first major refuge for a remnant herd of truly wild American bison, one that had existed there for millennia.

Although the formation of the first national park might seem a way to stop the slaughter of bison and other wildlife, it was not immediately successful, as hunting, legally or illegally, was common in Yellowstone's early years. In

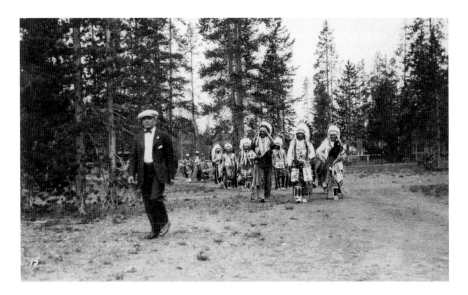

Mr. LaVatta led a group of Indians during an opening ceremony at Yellowstone National Park, 1872. *National Archives and Records Administration, no. 298653.*

1875, Park Superintendent Philetus W. Norris estimated that the slaughter of all kinds of animals for hides, meat and heads had claimed as many as seven thousand animals. The ongoing slaughter of wildlife prompted a very graphic illustration of wanton killing in *New York Magazine* in 1878. The loss of bison from Yellowstone National Park continued for several decades, from 1877, when about three to four hundred were reported, until there were just two hundred seen in 1894. Despite the work of many park gamekeepers and the patrols of the U.S. Army, Yellowstone bison were in serious trouble. In 1894, the official word from Yellowstone National Park was that unless extreme measures were taken to preserve the remaining bison in the park— the last wild herd in the United States—they were doomed.

In March 1894, a very compelling story emerged from Yellowstone National Park after a notorious poacher, one Edgar Howell, killed several buffalo in the park but was captured; several bison heads were confiscated by the U.S. Army, but Mr. Howell had to be released because there was no federal law with which to prosecute him. A story about the event was written by correspondent Emerson Hough from *Forest and Stream* magazine. The editor of *Forest and Stream* was George Bird Grinnell, an ardent supporter of and persuasive voice for bison conservation. He and his influential friends jumped on this opportunity and rushed to Washington, D.C., to meet with lawmakers. Their story drew much attention around the nation and

significantly increased public awareness about the plight of bison and other wildlife in Yellowstone, our first national park. As a result of this story, much public pressure and intense lobbying was aimed at Congress, and by May, a mere three months after the poaching incident, the Lacey Act of 1894, often referred to as the "Yellowstone Game Protection Act" was passed, finally including provisions to prosecute individuals under federal law in order to protect Yellowstone natural resources and wildlife.

Theodore Roosevelt demonstrated a strong personal interest in Yellowstone National Park. He visited Yellowstone for the first time with his growing family during a "grand holiday" in 1890. During that holiday, he became enthralled with the geologic wonders and wildlife of the region. He returned to Yellowstone in 1903 as sitting president. While in Yellowstone, he traveled for several weeks throughout the park with John Burroughs and Superintendent Major John Pitcher. While visiting Yellowstone for his second time, Roosevelt helped lay the cornerstone of the new entrance arch at the North Gate, near Gardiner, Montana, today referred to as the Roosevelt Arch.

To save Yellowstone and its bison, Roosevelt recruited the help of one of the many nongovernmental organizations he helped create. At the Boone and Crockett Club's first formal meeting in 1888, it joined in the battle to save Yellowstone National Park and initiated its first club project "to promote useful and proper legislation toward the enlargement and better government of Yellowstone National Park." The Boone and Crockett Club, led by Roosevelt, was looking beyond saving the great geologic features of the park and sought to protect its unique wildlife resources for future generations. It campaigned through 1894 to finally get the Yellowstone

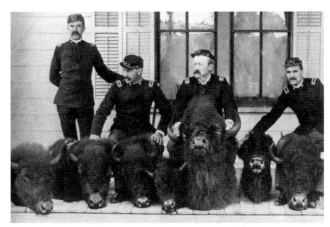

Members of the U.S. Army's Sixth Cavalry pose with buffalo heads seized in March 1894 from Cooke City poacher Edgar Howell. *National Park Service photograph.*

Above: Northern gateway to Yellowstone Park. The scene at the cornerstone laying by President Roosevelt, Gardiner, Montana, 1903. *Library of Congress.*

Opposite, top: At camp in Yellowstone, 1903.

Opposite, bottom: President Roosevelt and the noted naturalist John Burroughs at Fort Yellowstone, Yellowstone Park, 1903. *Library of Congress.*

Game Protection Act passed in Congress to enlarge the park and increase protection of wildlife, especially the remnant bison herd so important to that system. Even with that added protection, the remnant bison herd had dwindled down to a mere twenty-two animals by 1902. The government also reintroduced eighteen new animals from private herds and carefully husbanded this captive herd.

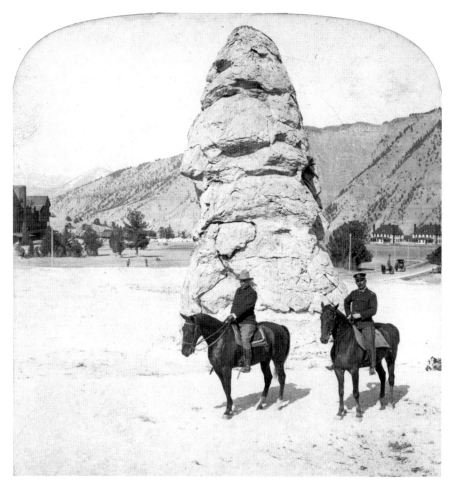

President Roosevelt's western tour—visiting Liberty Cap, Yellowstone National Park. *Library of Congress.*

Congress began to see the danger bison were in and in 1902 appropriated $15,000 to establish a buffalo ranch in Yellowstone National Park to propagate a bison herd under controlled conditions. With appropriate resources and careful management, Yellowstone bison rebounded, and today they number over four thousand animals. The leadership and persistence of Roosevelt as the president of the Boone and Crockett Club helped achieve this early victory for American bison.

Although Yellowstone bison were protected by the early 1900s, other federal and state efforts to protect wild bison had been limited in scope and

effect. At that time, fewer than two hundred bison were being protected by elected governments. Indeed, legislative and governmental failure to protect bison can be seen as the important stimulus that prompted the citizen public sector to act unilaterally to try to save the American bison. Progressive and determined men and women self-organized for the first time to save a wildlife species from extinction.

Historical records show that Ernest H. Baynes was one of the first people to actively promote and champion the idea for a national society to conserve bison. He was a writer, naturalist and animal trainer who served as conservator of the Corbin Park in New Hampshire in 1904. Baynes was moved by the sight of captive bison held at that nature preserve. His decorative letterhead featured a photograph of American bison with a title beneath it that read, "Save the Buffalo." He used his extensive social network and began a letter-writing campaign to enlist support. He also lectured widely about the plight of bison and published several articles in magazines and newspapers. He presented to the Brooklyn Institute of Arts and Sciences, the Camp-Fire Club of America, the Harvard Travelers Club and the Boone and Crockett Club. For nearly a full year, he constantly nudged William Hornaday to use the New York Zoological Society as the host vehicle for launching a new society for the protection of the American bison. Baynes shared his ideas

Yellowstone Buffalo Ranch in the Lamar Valley. *National Park Service photograph.*

with William Hornaday throughout 1905 and enlisted associates who could help launch this initiative.

Beginning in September 1904, Ernest Baynes began sharing his ideas with Theodore Roosevelt about restoring bison in North America. During the Christmas season of 1904, Roosevelt spent an evening with Baynes, when they discussed places to restore bison in the West and the collection of animals needed to save the species. They even went so far as to hatch a plan for the U.S. government to buy bison from private stocks held by Howard Eaton and Charles Goodnight. After the election of 1904, Roosevelt openly shared the idea of creating big game preserves (including bison) in his fourth annual message to Congress. This is the only time a bison conservation message has ever been included in any major speech by a sitting president. Baynes encouraged Roosevelt to become honorary president of a new organization to save the American bison.

Early in 1905, Baynes began actively pushing William Hornaday to host a meeting of supporters to save American bison. Hornaday readily agreed and wrote to the president of the executive committee for the New York Zoological Society, Charles T. Barney, in March 1905, calling for a partnership with the national government to establish semi-wild herds of bison. It is interesting to note that in this letter, Hornaday mentioned that preserving bison only at zoological institutions would not save the species from extinction. Hornaday recognized that bison thrived best when they ranged across "feeding grounds in a state of practical wildness." He referred to the success of the "Allard" (Pablo-Allard) herd in the Flathead Valley of Montana as the model for future restoration efforts in a semi-wild state.

In 1905, Baynes and Hornaday discussed hosting this first meeting in Washington to ensure the attendance of President Roosevelt. However, they eventually opted to host it at the Bronx Zoo in New York, even if this would be difficult for the president to attend. The original invitation to attend this inaugural meeting at the Bronx Zoo on December 8, 1905, was sent through Ernest Baynes to about two hundred people. Of these, fourteen individuals (thirteen men and one woman) attended that auspicious meeting, and the American Bison Society was formed to preserve a significant American icon. Although Roosevelt was unable to attend, he routinely corresponded with Mr. Baynes and offered consistent support for their initiative.

The American Bison Society was truly an international effort, spanning across North America. At that first meeting, Professor Franklin W. Hooper of the Brooklyn Institute of Arts and Sciences suggested that since there were many buffalo herds in Canada, the American Bison Society should invite

This page and following: "An Appeal for the Buffalo," a three-page brochure produced by American Bison Society.

AN APPEAL FOR THE BUFFALO.

The American Bison or Buffalo, our grandest native animal, is in grave danger of becoming extinct; and it is the duty of the people of today to preserve, for future generations, this picturesque wild creature which has played so conspicuous a part in the history of America. We owe it to our descendants, that all possible effort shall now be made, looking to the perpetual increase and preservation of this noble animal, whose passing must otherwise soon be a matter of universal and lasting regret.

It is conceded, practically by all authorities, that, owing to the uncertainties of human life, and the changes in fortune and in policy among private individuals and private corporations, the Buffalo cannot be perpetuated for centuries and preserved from ultimate extinction, save under government auspices. At present nearly all the Buffaloes in the United States are in private hands, and with few exceptions are for sale to anyone offering a reasonable price. Many are sold every year, some for propagating purposes, and others to the butcher and the taxidermist. Moreover, most of them are in a few comparatively large herds, and should contagious disease at any time strike one of these, so great a percentage of the now remaining Buffaloes might be wiped out at one blow, as to make the perpetuation of the remainder practically an impossibility.

In the belief that Americans generally will be found in sympathy with a carefully planned movement to save what might well be termed their national animal, and in order that all who desire may take part in the work of preservation, there was recently organized, in New York City, The American Bison Society, which, in accordance with its constitution, has for its object, " the permanent preservation and increase of the American Bison."

This society will seek to have established in widely separated localities, under government auspices, several herds of Buffalo, on suitable ranges (preferably government land), such ranges to be chosen from a large number that have been recommended by competent persons. These herds, under proper management, should increase until the race was no longer in danger of extinction.

With this end in view, The American Bison Society is now beginning an active campaign. A bill calling for national aid in the establishing of several Buffalo herds is already under consideration. In the meantime, the society purposes to make a determined effort to organize the interest of the public in the fate of the American Buffalo, and presently bring it to bear in such a manner that it will result in the governments of both the United States and Canada taking active measures to insure that animal's preservation and increase. The officers of the society are prepared to do the work incidental to this campaign, but in order that this work may be carried on promptly and vigorously, they must have the support of those whom they believe to be in sympathy with them. This support can best be given by joining The American Bison Society, and by urging others to join it. The work to be done requires money, and for this the society depends entirely upon membership fees and dues, and occasional private subscriptions.

the premier of Canada and the governor general of Canada to become part of this organization. At the first regular American Bison Society annual meeting in January 1907, the Honorable Earl Grey, governor general of Canada, was elected as honorary vice president. Although the American Bison Society was largely focused on creating U.S. bison herds, it often discussed and supported Canada's efforts to restore wood and plains bison. Maxwell Graham, in charge of wildlife matters in the Canadian territories,

Several forms of membership have been created, and the fees and dues have been arranged with a view to enabling each person to contribute whatever he or she can afford. All members will be kept in touch with the society's work and informed of its progress. If those who love our native animals will stand together now, the Buffalo can be saved; in a few years it may be too late.

We do not think it necessary to ask Americans to perpetuate the Buffalo because of its commercial value. To be sure its flesh very closely resembles domestic beef, and its hide is much more valuable than that of any domestic animal we have. Moreover, the results of the few experiments which have been made in cross-breeding seem to indicate that by crossing the Buffalo with certain breeds of cattle, it may be possible to produce a new and valuable farm animal, with a thick coat of fine soft hair. But we believe that the famous old Buffalo has a far better and far stronger hold on the American people than can be estimated in dollars and cents. We know that he is a typical American animal,—the most conspicuous that ever trod the soil of this continent, and all things considered, perhaps the grandest bovine animal of our time. Americans will remember that his history is interwoven with their own,—with the development of the great West, and with the history of our Indians and of the pioneers. They must never forget the part played by the Buffalo in those rough times when the comfort, and even the very existence, of thousands of men depended on the presence of this huge and shaggy beast.

The extinction of the Buffalo would be an irreparable loss to American fauna; more than that, it would be a disgrace to our country. The passing of any great and noble animal is a calamity which all thoughtful persons should seek to avert. But the Buffalo has a special claim upon us, inasmuch as the great services he rendered the country in early times were repaid with indescribable brutality and persecution. By a series of cold-blooded massacres never equalled by any other nation calling itself civilized, a great race of animals numbering countless millions was reduced to numbers so pitifully small that for a time it was regarded as practically extinct. The least we can do now to partly atone for this ruthless slaughter, is to join in measures to prevent what must otherwise be the final result of perhaps the greatest wrong ever inflicted by man upon a valuable wild animal.

Respectfully submitted,

THE AMERICAN BISON SOCIETY.

often reported to the society about efforts to restore bison. Interest in Canadian bison conservation rose considerably after the American Bison Society purchased the Pablo-Allard herd located in Montana in 1906 and the roundup of those wild bison from 1907 to 1912 for shipment into Alberta, Canada. Norman Luxton from Banff, Alberta, photographed and documented this great roundup of the herd destined for Canada, and the event was widely publicized. It was discussed by the American Bison Society,

which with help from Theodore Roosevelt, was desperately trying to buy these bison for restoration projects in the United States.

Besides Roosevelt and Hornaday, the American Bison Society included many other notable characters involved with wildlife conservation and New York society: Gifford Pinchot (founder of the United States Forest Service), Andrew Carnegie, Austin Corbin, Ernest Baynes, Harold Jefferson Coolidge (whose son was co-founder of International Union for Conservation of Nature and the World Wildlife Fund), the Honorable Earl Grey, Howard Eaton, William L. Mellon (father of the founder of Mellon Foundation), Ernest Thompson Seton (co-founder of Boy Scouts), Commander Robert E. Peary (the famous explorer), Madison Grant (of Save the Redwoods League), Charles Goodnight (Texas Ranger, rancher and early bison conservationist), C.J. Buffalo Jones (adventurer, rancher and early bison rancher/conservationist), Morton Elrod (professor at the University of Montana) and the Charles Conrad Estate (of the bison rancher/conservationist).

Roosevelt routinely used his position as U.S. president to help the New York Zoological Society and the American Bison Society secure land,

Founding members of the American Bison Society meet at the Lion House in the Bronx Zoo, New York, 1905. *Wildlife Conservation Society and Archives.*

procure buffalo and promote bison reintroduction projects. He mentioned the concern for bison in his annual message to Congress on December 5, 1905, during his second term as president. The first three premier bison restoration projects supported by Roosevelt and the American Bison Society included Wichita Mountains Reserve, Wind Cave National Park and the National Bison Range. Each of these bison projects was led by the American Bison Society and accomplished through the direct influence of Roosevelt's presidential power to save wildlands in the West.

Comanches and Kiowas considered the Wichita Mountains sacred and desired to see buffalo there once again. In a letter to Roosevelt, the Comanches wrote, "Tell the President the buffalo is my old friend and it would make my heart glad to see a herd once more roaming about." The Wichita National Forest and Game Reserve was originally designated as a reserve on June 2, 1905, through proclamation by President Roosevelt and was the first game reserve in the United States. Due to quick action on the part of the American Bison Society and William Hornaday, a group of fifteen bison was assembled and offered by the Bronx Zoo as a donation to the U.S. government, provided a portion of the reserve was fenced for them. Roosevelt immediately obtained Congressional approval of a bill appropriating $14,000 for enclosing fourteen square miles of range for these bison. They transported bison from the Bronx Zoo to the new Wichita Reserve by train and freight wagon for release in the autumn of 1907. Quanah Parker was on hand during the release, and it was a very emotional homecoming. In 1936, Congress renamed the reserve the Wichita National Wildlife Refuge, today home to more than five hundred bison.

In 1908, William Hornaday enlisted the help of Morton Elrod, a professor at the University of Montana, to identify and map a future range for bison on the Flathead Indian Reservation. Feeling somewhat embarrassed by the missed opportunity to buy the Pablo herd two years earlier, the U.S. Congress approved money to buy and fence land for a new buffalo range, but it was up to the American Bison Society to raise $15,000 to purchase buffalo from the Conrad family. In 1909, the American Bison Society made the arrangements and put these Conrad bison (formerly Allard's bison) on the newly formed National Bison Range. The new National Bison Range also received 1 bison from Charles Goodnight of Texas and 3 from Austin Corbin of New Hampshire. Today, the National Bison range is one of the premier sites to view and enjoy bison. The herd of about 350 now routinely provides live bison

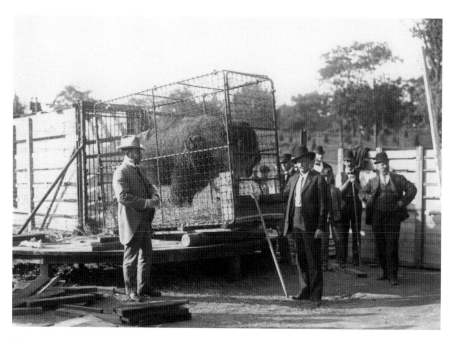

Shipping bison from the Bronx Zoo, New York, to Wichita Mountains in Oklahoma, 1907. *Wildlife Conservation Society Library and Archives.*

for restoration on tribal lands. Recently, bison from the National Bison Range were gathered and shipped to the new Rocky Mountain National Wildlife Refuge near Denver, Colorado.

Wind Cave, in the South Dakota Black Hills, is considered sacred by the Lakota people as the place where the "buffalo woman" came out and gave bison to her people. As Roosevelt and others were seeking natural wonders to preserve in the early 1900s, Wind Cave was brought up by Robert J. Gamble of South Dakota as a remarkable place that deserved protection. In June 1902, Congressman Lacey, of Illinois, introduced a bill to protect Wind Cave as the seventh national park. Roosevelt enthusiastically signed the bill into law on January 9, 1903, to establish Wind Cave National Park. Almost immediately, the American Bison Society set to work planning for a bison reintroduction to this park. Despite the park's early formation in 1903, the American Bison Society did not reintroduce bison to Wind Cave National Park until 1913. Today, this is one of the prominent national parks where people can come to view and enjoy a semi-wild bison herd.

In 1872, Samuel Walking Coyote, a Pend Oreille Indian, was hunting with three Blackfeet near Buffalo Lake in northern Montana. These native

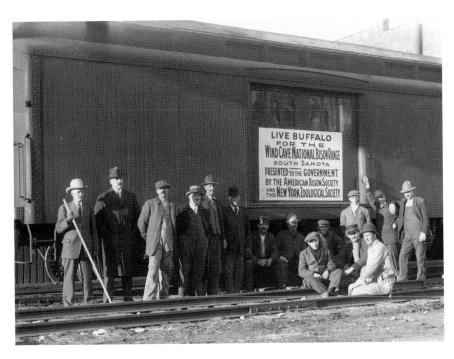

Bison are loaded into train cars at Fordham Station near the Bronx Zoo and are headed to Wind Cave, South Dakota, 1913. *Wildlife Conservation Society Library and Archives.*

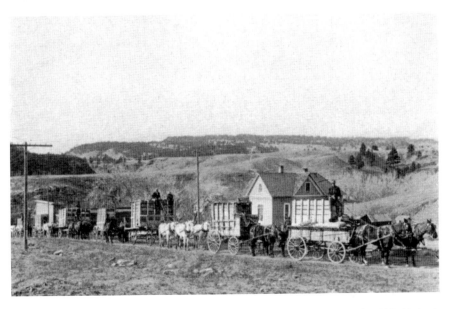

Bison wagon train headed for Wind Cave National Park from Hot Springs in 1913. *National Park Service photograph.*

hunters captured six or eight buffalo calves (depending on various versions of this story) that spring, and eventually Samuel Walking Coyote trailed these calves back to the Flathead Valley, where they were husbanded for a short while. The Pablo-Allard herd was originally founded from thirteen animals purchased from Samuel Walking Coyote in 1884 by Charles Allard and Michel Pablo for $2,000. The herd had grown to more than three hundred animals by 1895, when Charles Allard died from an injury. After Charles Allard passed away, the herd was split, and Allard's portion was sold to Charles Conrad from Kalispell, Montana. The remaining herd was husbanded by Michel Pablo until 1906, when he could no longer keep them on the Flathead Reservation because it was divided into homesteads. When Theodore Roosevelt heard that the Pablo-Allard herd was going to be sold, he made an appeal to Congress to buy this incredible herd of bison. Congress would not appropriate the money, and the herd was eventually sold to Canada. It took six years (1906–12) to capture and ship these bison to Canada. The loss of this opportunity to keep the Pablo-Allard herd in the United States was a major disappointment to Roosevelt and the newly formed American Bison Society.

William Hornaday retired as president of the American Bison Society in 1911, and he declared that bison were no longer an endangered species. The last bison herd the American Bison Society helped establish was in North Carolina in the Pisgah National Forest and Game Preserve, formed in 1915. In 1919, bison were donated by American Bison Society member Austin Corbin and released onto the game preserve. On January 16, 1919, Teddy Roosevelt died, and bison lost one of their most influential advocates. By 1922, the American Bison Society was reporting that bison were now abundant enough to generate surplus animals. The society then began to take greater interest in restoring pronghorn in the United States. In 1930, the American Bison Society published its last report and considered the bison species saved. William Hornaday, last of the great bison champions, retired from the Bronx Zoo in 1936 and died on March 6, 1937.

The bison success story is still being written, as new conservation efforts are underway to maintain viable populations and preserve this icon of our national heritage. From small beginnings arose more than a century of conservation action. In 1903, W.C. Whitney, who had earlier purchased ten bison from C.J. (Buffalo) Jones, a former buffalo hunter turned rancher, donated his herd of twenty-six animals to the New York Zoological Society. These bison then joined seven that were purchased by William Hornaday from C.J. Jones and Charles Goodnight. These thirty-three animals formed

the nucleus of the herd at the Bronx Zoo that was used to restore bison in the West.

And now again, the Bronx Zoo is undertaking unprecedented steps for bison conservation. The zoo is now working with Colorado State University to utilize embryo transfer techniques to yield bison of Yellowstone lineage for eventual restoration. However, since 2012, embryo transfer has produced only one viable bull calf after dozens of failed attempts. This lonely bull was named Little Big Head and has patiently waited his turn to sire bison calves with suitable bison cows. To speed the process of establishing a new bison herd at the Bronx Zoo, the Wildlife Conservation Society opened conversations with the Fort Peck Reservation to acquire breeding age bison from its herd.

The Fort Peck Assiniboine and Sioux Tribes in Montana have been husbanding bison from Yellowstone National Park that graduated from a U.S. Department of Agriculture–approved brucellosis quarantine program near Yellowstone National Park and are certified disease-free. This new herd lives on a large expanse of native grasslands that the tribe owns and has grown to 350 in just six years. As the herd expands beyond the tribal grasslands' carrying capacity, bison are becoming available for conservation

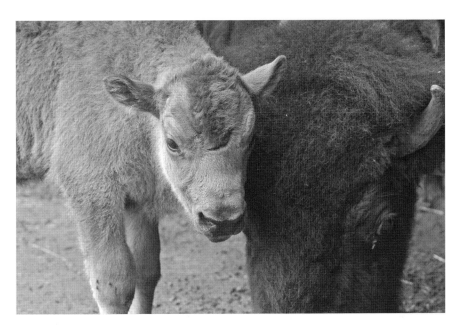

First American bison calf with Yellowstone genetics born through embryo transfer at the Bronx Zoo, 2012. *Photograph by Julie Larsen Maher, WCS.*

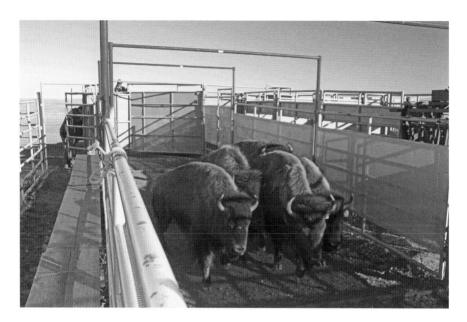

Loading eight bison to be shipped to the Bronx Zoo, New York City, from the Fort Peck Reservation in Montana, November 2016. These are genetic descendants from Yellowstone National Park that have passed through extensive quarantine procedures. *Photograph by Keith Aune.*

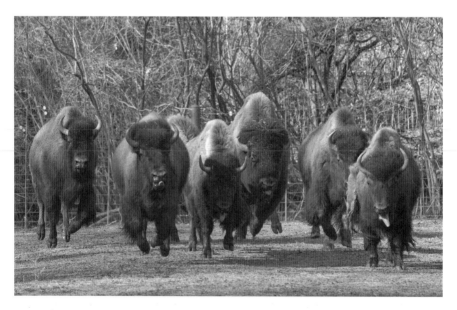

Yellowstone bison in paddocks at the Bronx Zoo. These bison were gifts from tribes of the Fort Peck Reservation in Montana and the one bull bison from embryo transfer research, 2017. *Photograph by Julie Larsen Maher, WCS.*

projects in North America. On November 12, 2016, a generous gift of 8 bison (7 females and 1 male) was shipped to the Bronx Zoo from the Fort Peck Reservation buffalo pastures. Since many of these females were bred in the late summer rutting season, before shipment to the Bronx Zoo, they delivered 6 new calves during the spring of 2017. The Bronx Zoo is now hosting 15 bison from the Yellowstone lineage to help advance bison conservation.

By establishing a genetically reputable bison herd, the Bronx Zoo will, in essence, return to its roots dating back to the early 1900s. The zoo will once again raise bison to establish herds in other accredited zoos and for future bison restoration programs in the West. Promulgating its tradition of connecting zoos to recovery of animals in the wild, the Wildlife Conservation Society hopes that more zoos will be proactive in partnering across the country to "bring more buffalo home" to native habitats.

CONSERVATION AND HUNTING

By Jim Posewitz

There was more in the founding of the United States of America than the civil and human liberties articulated in the Declaration of Independence, Constitution and Bill of Rights. Subtly buried in these precious documents and their noble purpose was the potential to create a unique relationship between ourselves and nature. That potential began being legally addressed sixty-six years after our founders signed the Declaration of Independence. The dispute involved fishing oysters in the New Jersey Meadowlands over land granted by the king of England to his brother in colonial times. That grant included the "fishings, hawkings huntings, and fowlings." In 1842, the U.S. Supreme Court found in favor of the fishermen by virtue of the fact that our Declaration of Independence declared the people in our "New World" democracy were sovereign. In that capacity, the wild fish and game belonged to the people to be managed as a public trust by the state. In short, the king's deer became the people's game. What lay ahead on the American landscape was a rough ride, especially for the buffalo.

To put our search for a fish and wildlife conservation ethic, as a component of our relationship with nature, into perspective, the 1842 Supreme Court decision was reached sixteen years before Theodore Roosevelt was born.

Sixteen years after he died, I was born. This relationship with nature—which our current iteration of "civilized man" struggles with—is a relatively new phenomenon. No species of wildlife was, or is, more entangled in that struggle than the buffalo. Citizen hunters played a significant role as a uniquely American conservation ethic formed, and the democracy of the wild emerged, in our culture. Likewise, the iconic buffalo was and remains a fellow traveler in this odyssey. Populations of these animals, extirpated to within a whisker of extinction, now challenge us to achieve a restoration commensurate with the agony we imposed on them.

Early in American history, there was little thought given to our relationship with nature, other than exploiting the natural abundance North America offered. In the mid-1800s, curious Europeans sent French nobleman Alexis de Tocqueville over to study democracy in America. He reported, "In Europe people talk a great deal of the wilds of America, but the Americans themselves never think about them; they are insensible to the wonders of inanimate nature. Their eyes are fired with another sight; they march across these wilds, clearing swamps, turning the courses of rivers."

Perhaps the nobleman De Tocqueville perceived a flaw in the democratic notions fueling the engines of a young country recently born of revolution. At the time, there was little indication that America would find a conservation ethic big enough to create an American commons out of which national forests, a wilderness system, parks, national monuments, wildlife refuges, game ranges, a wild and scenic river system and hunting for every American with the desire might emerge.

There were voices raised on behalf of a better relationship with the natural wonders, falling before our national exuberance. Ralph Waldo Emerson (1803–1882), Henry David Thoreau (1817–1862) and George Perkins Marsh (1801–1882) all thought, wrote and lectured for a more sensitive relationship with nature and natural resources. They were called the "Concord Transcendentalists," and while their following was ardent, it was limited. When they passed through their senior years, the buffalo of the Great Plains were being relentlessly slaughtered.

Nature's advocates, the Concord Transcendentalists all thought, wrote, lectured and died before a twenty-four-year-old New York State legislator found and killed a lone wandering buffalo just after North Dakota's last commercial slaughter. In September 1883, a young Roosevelt arrived in Little Missouri, North Dakota, borrowed a gun big enough to kill a buffalo and hired a local to guide him in his pursuit of a boyhood fantasy. It took more than a week to find a lone wandering survivor on Little Cannonball

Creek, Montana Territory. Here is how he described the moment: "On the ninth day it culminated....I crawled up to the edge, not thirty yards from the great, grim looking beast, and sent a shot from the heavy rifle into him just behind the shoulder, the ball going clean through his body. He dropped dead before going a hundred yards."

A mere six years later, he would shoot another buffalo, this time in Idaho, just south of the Montana border. His reflections of that moment give us a dramatic contrast, following the epiphany that occurred in his life between 1883 and 1889. This change in a hunter's perspective, attitude and commitment was the epiphany of a recreational or sport hunter. Emerson, Thoreau and Marsh were all deceased, and the latent American conservation vision was seized by Roosevelt, George Bird Grinnell and Gifford Pinchot. All were hunters. In time, a wilderness system, and wild and scenic river system, would emerge from that base. At its core was the introduction of the sporting code and the belief that we could restore wild, free roaming and public wildlife to an entire continent.

One generation later, while this latent conservation ethic was emerging across the nation, an economic depression and drought hit our country. These events produced the "Dust Bowl," a period remembered as the "dirty thirties" and what author Timothy Egan described as America's *Worst*

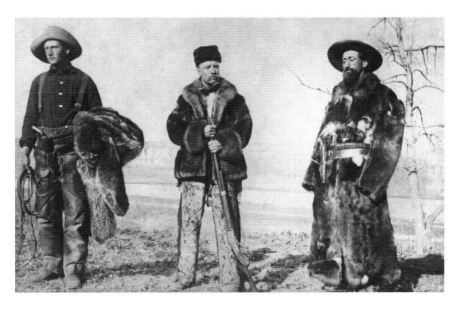

Teddy Roosevelt with Wilmot Dow and Bill Sewall at the Elkhorn Ranch in 1886. *Library of Congress.*

Hard Times. Right in the middle of that dirty decade, President Franklin D. Roosevelt called the first North American Wildlife Conference in 1936. Hunters and anglers from across the nation assembled and were told by the president that if wildlife was to be saved, they, at the grass-roots level, would need to take action. They did, and they formed national citizen-based organizations to take on the challenge. In addition, they taxed themselves to pay for the effort.

In 1937, one year after the first North American Wildlife Conference, the Pittman-Robertson Act taxing firearms and ammunition to pay for wildlife restoration was introduced in Congress. It went from introduction to presidential signature in ninety days! Today's wildlife abundance is testimony to the fact that it worked. The irony of it all is that it still does not fully include the animal that suffered and continues to suffer the most abuse at our hands: the buffalo.

It is time we set our sights on something better for the buffalo. They have and continue to endure too much abuse. We can and must do better. We have demonstrated that ability with a broad spectrum of wildlife as a public trust resource. It is critical that we afford wild buffalo a place and, in the process, bring the North American wildlife restoration effort full circle. The American hunter/conservationist community is ready for this challenge. Our movement began amid the rotting buffalo carcasses on the Northern Plains 130 some years ago. Today, we are within reach of restoring both the buffalo and a good bit of their wildness to the very same ground. We need to generate the political will to just do it!

When it is done, we can stand before the American people and proudly proclaim that we found a way. We found, created and executed a plan that has come full circle and produced one of our democracy's greatest environmental achievements. We will have taken an exploited, battered and abused natural resource and restored it in more than a token sense. Humanity will soon address environmental calamities of global proportion. It would be good to show the world a plan that worked, at least on a continental basis. Thus, there is reason to hope. That will be a desperately needed commodity as we, and the buffalo, search for a place on a changing planet.

LEGACY BISON: BLACK DOG, FROM EASTERN ZOO TO WESTERN CONSERVATION HERD

One of the bison William Hornaday was most proud of was Black Dog. In a twist of fate, this bull, who was raised in a small paddock at the Bronx Zoo, became famous by participating in one of the first bison conservation efforts in North America. In 1901, the Kiowa-Comanche Indian Reservation was opened for settlement by an act of Congress. To protect some of the natural grazing and forested lands, Congress set aside 60,800 acres of the Wichita Forest Reserve, and it was subsequently designated by Theodore Roosevelt as a game preserve on June 2, 1905.

Black Dog was born in the Bronx Zoo in the spring of 1907. He was one of the original fifteen bison transferred from the Bronx Zoo to the Wichita Mountains Forest and Game Preserve, now a wildlife refuge, as part of the first field restoration project by the American Bison Society. On October 11, 1907, fifteen buffalo boarded a train in New York City and made the long and historic journey to the brand-new state of Oklahoma. The bison traveled 1,858 miles from Fordham Station, New York, to paddocks in Cache, Oklahoma, over seven days. Perhaps this undertaking could be viewed as compensation for the killing of twenty-four bison in 1886 for the

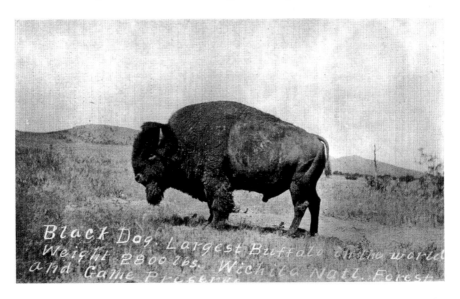

Black Dog, one of Hornaday's favorite bull bison that was part of the original shipment of bison from Bronx Zoo to Wichita Mountains, photographer unknown. *Published in the 1917 American Bison Society Report.*

taxidermy collection of the Natural History Museum. According to William Hornaday, the bison were a "gift to the people, for the express purpose of helping to preserve the American bison from ultimate extinction." A Kiowa prophesy predicted the return of bison from the Wichita Mountains pouring forth like rivers of living water. Both Kiowas and Comanches, including the famous warrior Quanah Parker, came to witness the unloading of bison at Cache. Black Dog found his native home back on the range, and the spirits of the Kiowas and Comanches soared.

By 1917, the bison herd at Wichita had grown to 94 animals and included the now large bull Black Dog, reputed to be the largest bison in the world at 2,800 pounds. It is difficult to say how many calves Black Dog sired, but he most certainly contributed to the establishment of a healthy bison herd over his lifetime. The Wichita Mountains Wildlife Refuge now maintains the bison herd at about 650 animals, hosting more than 2 million visitors a year. What is significant about the story of Black Dog is that he was part of a set of historic firsts and the transformation of conservation from idea to action. While the Wichita Mountains was the first big game preserve in the United States, this was also the first time a bison bull calf raised in a New York zoo became part of successful reintroduction of bison to western plains and the first attempt to reestablish a federally owned and managed bison herd.

CONVERGENCE

Theodore Roosevelt first met Dr. William Hornaday in 1887, when Hornaday was chief taxidermist at the Natural History Museum. After a short but tense introduction, they discussed the taxidermy displays at the museum and shared their common interest in guns, adventure and natural history. It turns out that they were natural companions. Their association was intermittent for several years while Roosevelt was president of the newly formed Boone and Crockett Club and worked as Civil Service commissioner and New York Police commissioner.

During the late 1800s, there was a zoo-building craze taking root in the growing cities of the United States. These were mostly small menagerie-style zoos, with limited educational value. There was a National Zoo in Washington, D.C., of which William Hornaday was curator. In 1895, Roosevelt, acting in his capacity as president of the Boone and Crockett Club, formed a committee to look into forming a New York Zoological Society and a splendid New York Zoo. William Hornaday was appointed as the first director in 1896, and the New York Zoological Society was officially formed in 1897; the zoological park opened in 1899. Part of the Zoological Society's mission was to save species and to connect people, especially youth, to nature through a more natural presentation of live animals in the zoo.

Despite sometimes intense political wrangling and difficult social conflict over new conservation ideas and government policies, Roosevelt and the early conservation champions had set an unalterable course for bison restoration. They executed the first significant effort to rescue a wild animal

Theodore Roosevelt visits the Bronx Zoo in New York. *Wildlife Conservation Society Library and Archives.*

species otherwise headed for extinction in the United States and perhaps the world. Roosevelt and his colleagues succeeded in establishing and protecting bison herds that are now viewed as national treasures and soon became source stock for continued restoration yet today.

The last year of Roosevelt's presidency, he began to really strengthen and empower the conservation movement in the United States. In May 1908, he convened the first White House Conference of Governors to discuss conservation. In June of that year, he appointed a forty-nine-member National Conservation Commission, with Gifford Pinchot as chairman. In 1909, he convened the first North American Conservation Congress, which led to a second in 1910. His role, after launching the conservation movement, began shifting from the influence of few champions to one of broader inclusion and increased public support for nature conservation in order to secure the movement. This was a significant time of change for Roosevelt, when his conservation legacy would either be secured for posterity or gradually diminish after his absence.

Restoring nature was a hard and costly venture for Roosevelt's personal and political career. His willingness to exercise and expand presidential powers to preserve wildlands and restore wildlife under the Creative Act and Antiquities Act caused considerable Congressional grumbling. Roosevelt became very unpopular to some in his own political party and in several of the western states that he loved so much. In 1907, conservative western congressmen banded together to pass an appropriations bill that banned the president from creating any new forest reserves in six states.

With the end of his second term as president, Theodore Roosevelt hoped that his conservation legacy and bison restoration might continue under the Taft presidency. He was wrong. Taft almost immediately began unraveling the conservation successes so prominent in Roosevelt's term. In addition, Taft began replacing the conservation champions in key government positions with others who were inclined to exploit natural resources with abandon. When Taft fired Roosevelt's good friend and early conservationist Gifford Pinchot on January 7, 1910, Roosevelt was very unhappy. Not long after, it became evident that Roosevelt was going to take a run at unseating Taft and restoring his conservation legacy. This ultimately led to a split in the Republican Party and the eventual run by Roosevelt under a third party

President Theodore Roosevelt hosted the first Governors Conference on conservation at the White House in 1908, photographer unknown.

that became known as the Bull Moose Party. The result was that Democrat Woodrow Wilson won the election because of a highly divided Republican Party. Although Roosevelt did receive more votes than Taft, he was ultimately not able to gain the presidency, although his conservation legacy then lived on, as carried by many others he had recruited.

The gift of Roosevelt and his colleagues was not only spectacular wildlife, lands and waters but also the many people he recruited for the cause, the culture of conservation they created and a permanent organizational structure that evolved around this new conservation vision in America. Fundamental to this new vision was the establishment of multiple natural resource agencies, embedded within federal and state governments, and the development of a complementary suite of nongovernmental organizations, with special advocacy interests to facilitate citizen support for various conservation measures. As a result of these organizations, we continue to hear the call for wildlife conservation from the Audubon Society, Boone and Crockett Club, Campfire Club, American Bison Society and Wildlife Conservation Society. As a result of these early conservation champions, we also have a National Park Service, U.S. Fish and Wildlife Service, U.S. Forest Service and other resource agencies to guide the nation in the scientific management of our national natural heritage. This organizational framework is the lasting legacy of the early pioneers who invented the practice of nature conservation.

The early experiments in bison and wildland conservation gave us several important principles for the next era of wildlife conservation. The first lesson was that a modern scientific approach is critical to charting and executing any species restoration plan and managing our wildlands. A major part of Roosevelt's personal legacy stems from his desire to practice good science in preserving habitat and recover species like the American bison. With his educated outlook and natural resource background, he assembled the right team of scientifically trained colleagues at the right time to implement conservation and species restoration that was evidence-based. The second critical lesson these early conservation efforts emphasized was the need to preserve adequate habitat, and even entire functional ecosystems, for wildlife to persist in the long term. Roosevelt readily took on the challenge of saving a future homeland for the American bison and other wildlife through designation of national forests, refuges, monuments and parks, all of which ensured the growth and success of restoration efforts. Finally, these early champions of bison and wildlife conservation taught us the importance of building public and political support for the important work to be done.

They artfully crafted essential legal and policy frameworks, around which we can still accomplish wildlife conservation today, and helped to create a citizen advocacy legacy and system to strongly advocate for appropriate government policies and laws.

As inspiring words from progressives and reformers spoke elegantly about nature, tickling the ears of young Theodore Roosevelt, he, in turn, weaved an intricate network among conservation-minded friends and colleagues to converge on the idea of saving the natural world. The human network he created can then be traced forward through an impressive lineage of conservation champions up through today. For example, Gifford Pinchot, a close friend and ally, was hand-picked by Roosevelt to lead the newly formed U.S. Forest Service in 1905. Pinchot was a graduate of Yale School of Forestry, and his family endowed that school. None other than Aldo Leopold, who later became the father of modern wildlife management and ecology, attended the Yale Graduate School of Forestry, completing his studies there in 1909. After his formal training was complete, he went to work for the new U.S. Forest Service and became a part of what many at that time referred to as "Pinchot men." Leopold also hosted a western tour for the renowned Dr. William Hornaday from the New York Zoological Society, campaigning for the "Hornaday Plan" for national forests, wildlife refuges and game protection.

Leopold formed the Albuquerque Game Protective Association, which followed the Hornaday model. Roosevelt wrote to Aldo Leopold in 1917 to congratulate him for the work of that protective association and expressed agreement with an article Leopold wrote about wildlife in a newsletter titled the *Pine Cone*. Eventually, Leopold became a champion for all time with his own books entitled *A Sand County Almanac* and *Game Management*, which have become singularly important for all forestry and wildlife students since the early 1930s. Leopold's prose and stimulating nature stories revealed in *A Sand County Almanac* have inspired new conservation students for decades, carrying forward the legacy started with Roosevelt and William Hornaday.

These examples illustrate the intricate journey of conservation thinking, first conceived by New England transcendentalists like Emerson, Thoreau, Burroughs and Marsh. The seeds of this progressive thinking sprouted through the energetic actions of Roosevelt, William Hornaday, George Bird Grinnell and Gifford Pinchot and then matured through writings and actions from modern wildlife practitioners like Aldo Leopold. The teaching gradually flowered into a grand movement for modern scientific management of wildlife and wildland habitat. This is the critical

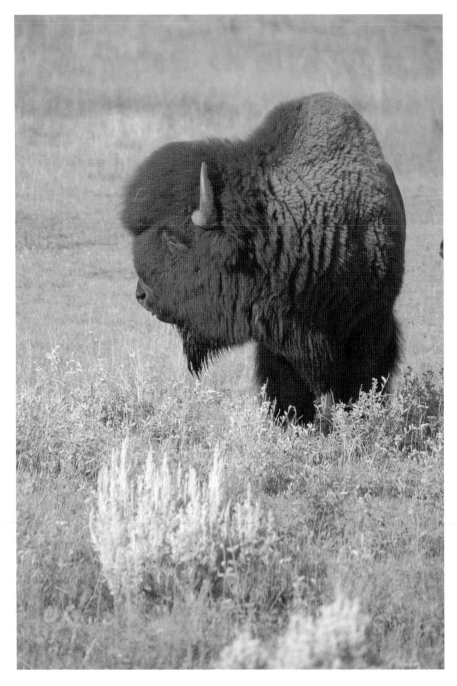

A large bison bull in regal pose from Yellowstone National Park. *Photograph by Keith Aune.*

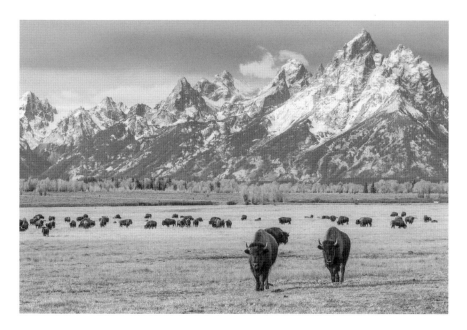

Bison herd at Grand Teton National Park. *Photograph by Jeff Burrell, WCS.*

convergence that blossomed out of a new way of relating to nature and living with wildlife, within modern society and governance, so that future generations can also experience true nature. Without this legacy, convergence of thinking and action, our world would have become a much different place and wild bison would likely have gone extinct.

THE FATHER OF BISON GENETICS

By James Derr and Dave Hunter

In the early 1990s, a scientific committee was established to gain a better understanding of the disease brucellosis in bison and elk in the Greater Yellowstone Area (GYA). One of the first invited scientists to speak with the committee was Dr. Joe Templeton, a geneticist at the College of Veterinary Medicine at Texas A&M University. He presented new information regarding how genetics play an important role in animal disease episodes and overall health. One of Dr. Templeton's first comments at this meeting

was that "bison are not cattle." This statement has proven to be correct in most comparisons made between these species. He also explained the importance of genetics for the restoration and preservation of bison. Dr. Templeton pointed out that documenting existing genetic diversity is critical for the long-term conservation of this species due to the severe population crash that occurred in the late nineteenth century.

Dr. Templeton proposed that bison at Yellowstone National Park were one of the only remnant bison herds that were not highly manipulated by humans, and they could possess unique gene variants that are potentially valuable in North American bison conservation. He pointed out that there was considerable interest by many Native American tribes to utilize these Yellowstone National Park bison to supplement existing herds or to start new populations. However, brucellosis infections were a serious threat to this strategy, and the use of genetic biotechnology could be an important tool to combat this disease.

Dr. Templeton pursued the mission to explore the genetics of bison and encouraged others to assist in his quest. He recruited Dr. James Derr to assist in these studies. Thus began the new era of using DNA-level molecular biology tools for bison genetics. More than a decade later, the ability to sequence the whole genome of an organism became technically and economically possible. It was decided that the time was right to sequence the bison genome, and the animal selected to represent this species was a bull from Yellowstone National Park. On a cold and snowy morning in March 2011, the chosen bison bull was safely captured, and genetic samples were taken. Samples from this animal were used to serve as the template for the very first bison genome. This bison genome effort was a collaborative project involving multiple federal agencies, the National Buffalo Foundation, the Turner Foundation, Turner Enterprises Inc. and Texas A&M University. Unfortunately, Dr. Templeton died before this quest could be accomplished. Fortunately, Dr. Jim Derr continued in the quest to understand the bison genome and pushed this project toward completion. Due to Dr. Templeton's foresight, influence and enthusiasm for fostering the use of biotechnology to help understand and better manage bison, it was a unanimous decision to name the reference genome bison "Templeton," after the person now considered the "father of bison genetics."

BISON CONSERVATION HERDS ON U.S. DEPARTMENT OF INTERIOR LAND
Compiled by Wildlife Conservation Society, March 2016

DOI Unit	State	Agency	Approx. Herd Size	Approx. Area Size (ac)
Book Cliffs	UT	BLM	450	1,400,000
Henry Mountains	UT	BLM	325	300,000
Fort Niobrara National Wildlife Refuge	NE	FWS	350	17,000
National Bison Range	MT	FWS	380	19,000
Neal Smith National Wildlife Refuge	IA	FWS	70	700
Rocky Mountain Arsenal National Wildlife Refuge	CO	FWS	75	12,000
Sullys Hill National Game Preserve	ND	FWS	25	540
Wichita Mountains National Wildlife Refuge	OK	FWS	640	59,000
Grand Teton National Park (GRTE) /National Elk Refuge*	WY	NPS / FWS	800	360,000
Badlands National Park	SD	NPS	650	64,000
Chickasaw National Recreation Area	OK	NPS	10	80
Grand Canyon National Park	AZ	NPS	300	23,000
Tallgrass Prairie National Preserve	KS	NPS	20	1,100
Theodore Roosevelt National Park	ND	NPS	500	70,000

DOI Unit	State	Agency	Approx. Herd Size	Approx. Area Size (ac)
Wind Cave National Park	SD	NPS	450	28,000
Wrangell-St. Elias National Park and Preserve	AK	NPS	110	100,000
Yellowstone National Park	ID, MT, WY	NPS	4,900	2,200,000
Grand Teton National Park (GRTE) /National Elk Refuge*	WY	NPS / FWS	800	360,000
Great Sand Dunes National Park and Preserve* (GRSA)	CO	TNC* / NPS	2,000	50,000
			12,855	**5,064,420**

Most herd sizes taken from 2014 DOI report; some are more recently estimated
**Grand Teton (GRTE) / National Elk Refuge bison herd co-managed by NPS and FWS.*
***Great Sand Dunes (GRSA) bison herd is currently managed by TNC on the Zapata Ranch within NPS and FWS jurisdictional boundaries.*

WOMEN OF BUFFALO

Across millennia, women of the Great Plains have been tightly connected to buffalo as keepers and practitioners of traditions, values, stories and ceremonies that provided long-term cultural continuity for most native Great Plains peoples; as keepers of deep knowledge and developers and practitioners of technology and skills that were crucial to survival of native peoples; and through continuing leadership, activism and scholarship that empowers recovery of bison on the Great Plains and beyond.

In her book *The Buffalo Hunters*, Mari Sandoz conveyed a creation story as told to her by a Pawnee elder wherein a "buffalo woman" leads both

buffalo and people out of a dark place underground onto the light of prairie grasslands along the Platte River, where they would live together forever. The Lakota recount a story of the White Buffalo Calf Woman who meets two young men hunting to feed their starving people. One man desired the woman and tried to touch her. But as he tried, the man was consumed by a white cloud and turned into a pile of bones. The woman spoke to the other young man, who showed her proper respect. She instructed him to return to his people and tell them she was coming. This holy woman brought the Lakota people a sacred pipe and taught them seven sacred ceremonies. When she left, she told the people she would return. As she walked away, she rolled over four times and turned into a female buffalo calf. The White Buffalo Calf Woman is of supernatural origin and central to Lakota religion. Her promise is seen as a pledge that buffalo will always be there to take care of the Lakota people. For native peoples, such stories conveyed powerful messages regarding values and traditions that defined their aspirations and relationships among themselves, with the buffalo and the larger world.

Women-only buffalo societies remain active today among several native Great Plains tribes. Among the Blackfeet tribes in Canada and the United States, there is a women's society called the *Motokiks*. It is a great honor to become a member of this prestigious women's society, which has great influence in the annual cycle of ceremonies and tribal decisions. At the annual Sun Dance, the celebrations cannot begin until the *Motokiks* meet in a special lodge inside the camp circle, where women of high standing hold special medicine bundles and women wear a buffalo horn headdress and perform a ceremonial dance of the motions of buffalo. For the Lakotas, Mandans and Hidatsas, the White Buffalo Cow (*Pte*) Society is a women's-only buffalo society. The Lakota word *pte* is a specific reference to a female buffalo. The *Pte* Society has historically performed important buffalo-calling rites, and the leaders are mature or elderly women. Members of the society have traditionally painted one eye a color based on their personal preference, typically blue, and tattooed black marks between their lips and chin; at certain ceremonial dances, the leader is said to have once worn a white buffalo hide blanket and danced while holding a bundle of twigs capped with eagle plumes. These all-women societies continue to embody how the revered the female gender is among buffalo people living on the Great Plains.

Amid the often harsh, historic life on the Great Plains, women were a source of life, strength and consistency. Women often assisted men in hunting and

harvesting of buffalo. However, once the harvest was made, women became the primary force among the tribe for transport, handling, butchering and industry of translating the massive animals into the myriad items that sustained and enhanced life on the plains. Women were the multigenerational keepers of the highly specialized knowledge about buffalo, including the anatomy of males and female buffalo of all ages, seasonal variation in buffalo behaviors and body condition and the technology and tools that were necessary to dismember a single or a large number of bison into the hundreds of different parts, all of which could be utilized in some fashion, including immediate and long-term food supplies, clothing, lodging, weapons, utensils, toys and, yes, even fashion. As anyone who has ever harvested a bison in the wild today can attest, it still takes friends and family working hard, and together, to honorably retrieve and process a buffalo so as to limit waste.

WOMEN INVOLVED IN THE EARLY YEARS OF BISON CONSERVATION

The role of women in the early conservation movement is often overlooked, but most certainly they were critically significant in many ways. Euro-American women emerged as artists, activists, scientists and writers who had a direct impact on the movement and in the lives of men who helped champion this movement. Women were very influential for Theodore Roosevelt in becoming a champion of the modern conservation movement. Roosevelt's mother, Martha, by turns encouraged and tolerated Theodore's interest in the natural world. She patiently engaged the developing "Roosevelt Museum" that housed her son's growing collection of stuffed birds and mammals from around the world. Roosevelt, in his own autobiography, highlighted the role of his Aunt Anna Bulloch, his mother's sister, who helped raise the children and often entertained them with stories of hunting fox, deer and wildcat; the lives of Daniel Boone and Davy Crockett; and riding horseback in Georgia. The loss of his first wife, Alice, and mother on the very same day, February 14, 1884, proved to be one of the most significant life events for Theodore, catapulting him into the western United States as a hunter and rancher in the Dakota prairies. Indeed, the tragic loss of the two most important women in his life catalyzed his rhetoric and dreams into action, resulting in exploration, hunting, cattle ranching and western adventures that served as an experiential foundation for his lifelong

conservation ideals. His second wife, Edith, fully understood these qualities of her husband and likewise provided strength and consistency during his long absences while conducting politics, exploring nature, hunting big game and advocating for wildlife conservation around the world.

Charles (Charlie) Goodnight, a former Texas Ranger and famous cattle rancher in Texas, is known for his efforts to save the American bison. In his early life, he had a long and colorful history in Texas and became very familiar with bison during the great destruction of the southern herds and while famously creating his JA ranch. By 1866, he had perfected a technique of using a rope lasso to capture young wild bison calves and then socially imprinting the calves to his horse! He eventually captured six calves this way that he gave to a ranching friend to help start a private bison herd. That effort eventually failed after his friend lost interest in the venture. In 1870, Charlie married Mary Ann Dyer, from a well-known Tennessee family who had recently moved to Texas. By the middle 1870s, the wanton slaughter of the southern bison herd had reached its peak, and Mary Goodnight was quite distressed by the imminent disappearance of this prairie icon. She is credited with compelling Charlie to go back to the prairie and use his unique skills to capture bison calves once again and bring them to their ranch.

In 1876, the same year as the defeat of Custer at the Battle of the Little Bighorn, Charlie considered his wife's request and then went out to the wild prairies, lassoed and brought his wife 4 young bison calves. Charlie then followed his wife's further admonitions and acquired several other bison calves from neighbors, and by 1887, they had gathered together 13 bison. In 1910, their bison herd had grown to about 125 animals, and Charlie became a well-known broker in the redistribution of these bison for conservation efforts at zoos and parks, including several bison taken to Yellowstone National Park to assist in the recovery of the park's dwindling bison herd. The Goodnight herd eventually grew to 250 animals and ultimately became the foundation for the most important bison conservation herd in Texas at the Caprock Canyons State Park. The credit for advocating the preserving this last remnant of the southern bison herd is rightfully that of a compassionate and determined Texas ranch woman, Mary Goodnight.

It is little known that many women supported the work of the American Bison Society and were instrumental in the purchase of bison for National Bison Range in Montana. In 1907, the American Bison Society commissioned Dr. Morton Elrod to conduct an assessment of suitable ranges in the Flathead Valley as part of national efforts to restore bison. Dr. Elrod evaluated four areas in the Flathead and, with substantial lobbying by the American Bison

Society, convinced Senator Joseph Dixon from Montana to introduce a bill to establish the National Bison Range. The Bison Range Act was attached to the Agriculture Appropriations Bill, which was signed by Roosevelt on May 23, 1908. The bill appropriated funding ($30,000) for the purchase of land but did not approve funding for purchasing bison. The American Bison Society then launched a campaign to raise $10,000 in private funding for the purchase of bison for this new range.

According to William Hornaday, one of the surprising features of the bison funding campaign was the immediate response of women. The very first donation for the creation of the National Bison Herd was $5.00 from Mrs. Emma L. Mee of Concord, Massachusetts. The second-largest sum raised by any one person was due to the efforts of Mrs. Ezra R. Thaye, also from Massachusetts. She had launched a local campaign and provided $510.00 to the campaign. Altogether, 112 women contributed $1,227.00 to the bison fund, and Hornaday stated in the 1908 American Bison Society Annual Report, "The result [of this campaign] has proven that he who thinks there is any laudable public enterprise that does not interest the intelligent women of America, makes a great mistake." The bison fund grew to $10,560.50 by January 1909, and the American Bison Society went forward with the purchase of bison for the new National Bison Range.

THE INCREASING ROLE OF WOMEN IN BISON CONSERVATION

By the middle of the twentieth century, women had become increasingly important in shaping a national movement to restore the American bison once again. Some women have shared their worldviews through the written word, while others conducted groundbreaking research and practiced sound conservation.

Mari Susette Sandoz (1896–1966) was raised on a Sandhills ranch in Nebraska and became an accomplished novelist, biographer, lecturer and teacher. She was one of the West's foremost writers and wrote extensively about pioneer life and the Plains Indians. Her writings about the American West were monumental works coming from the pen of a woman at a time when men reigned among western writers. Her 1954 book *The Buffalo Hunters* carefully chronicled the great destruction of bison and helped us better understand why bison nearly went extinct at the end of the nineteenth century. Sandoz persuasively explained how the fate of bison and native

people groups were not two stories but one. However, it could be argued that the concluding chapter about the end of a dream by the late 1800s left the story unfinished. We now know the journey of restoration for bison and the revival of native people groups from the Great Plains began slowly in the early 1900s and has progressed more earnestly since the 1960s.

From the 1960s through the 1990s, Dr. Mary Meagher served as a wildlife biologist at Yellowstone National Park and was affectionately known among her friends and colleagues as "Buffalo Mary." Mary initiated field surveys and research on bison at Yellowstone National Park in 1963 at a time when very few women were so represented in the National Park Service. Mary completed her PhD degree on Yellowstone bison in 1992 and continued her field studies uninterrupted until her retirement in 1997. Her field studies were truly breakthroughs in our understanding of wild bison life history, behavior and ecology and remain the longest-running series of bison population data in North America. In addition to remarkable efforts to better understand bison, Mary truly blazed a path for women in the National Park Service.

Thanks to these early trailblazers and a growing women's rights movement across our nation, there is now a whole generation of women within government agencies, nongovernment organizations and academic institutions advocating, championing and leading the conservation and management of bison. Exemplars of this leadership include Dr. Amanda Hardy, who has helped shape bison management while serving with the Wildlife Conservation Society and National Park Service; Dr. Jennifer Barfield, from Colorado State University, who has developed reproductive technologies to preserve bison genetics and is saving bison through the Fort Collins Foothills Bison Conservation Initiative; Dr. Kate Schoenecker, who is conducting research on bison at Great Sand Dunes National Park for the United States Geological Survey; Laura Paulson, who leads a Nature Conservancy restoration initiative in Mexico, restoring bison on the El Uno Nature Reserve; Lee Jones, from the United States Fish and Wildlife Service, who monitors the health of all bison on National Wildlife Refuges; Marieve Marchand, who has successfully advocated for restoration of bison at Banff National Park, Canada; Ali Fox, who as president of the American Prairie Reserve in Montana is leading the most ambitious bison landscape conservation project ever conceived; and three notable Blackfoot women, Cheri Kickingwoman, Paulette Fox and Amethyst First Rider, who have been activists in the Iinnii Initiative, which aims to ecologically and culturally restore bison to Blackfoot country. These women and many others are now bringing critically important energy and vision to the second recovery of American bison.

LOOKING FORWARD

F ew species enjoy a history as rich in archaeology, paleontology, legend and history as the American bison. Nor is there any other North American wildlife species for which the spiritual, cultural and political significance is so great. Yet the recovery of this species has been significantly impeded by periodic breaks in the human connection to the species. Even today, much work remains to reconnect people and bison and to raise awareness about the continued struggle to achieve ecological restoration of this great American icon.

Conserving one of North America's most iconic species has become a broader and more complex endeavor than it was a century ago, when Hornaday and Roosevelt started the American Bison Society's pivotal demographic rescue at the beginning of the twentieth century, what can be called the first recovery of American bison. However, the modern bison conservation community is still able to build on the foresight and national movement created by the early activists' launching of the American conservation movement. Modern conservationists are actively preserving the legacy of bison restoration by initiating what has been called the second recovery of American bison. This second recovery has evolved toward establishing ecologically functioning bison populations, and it will require renewed commitment and new champions to be successful. This modern effort promotes the ecological restoration of American bison at larger scales, with broader collaborations among a wide range of partners, including government agencies, nongovernment

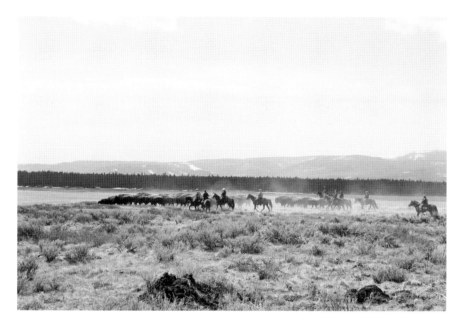

Hazing bison back into Yellowstone National Park near West Yellowstone, Montana, 2004. *Photograph by Keith Aune.*

organizations, universities, sportsman groups, producer groups, industry and Native American groups. Ecological restoration aims to bring back the ecological functionality of bison, which is expressed when practiced at the proper geographic scale, and enables natural selection to operate, inspires humans to support it and propagates enduring populations that are demographically robust.

Perhaps most importantly, ecological functionality includes tightly coupled linkages with human experiences, including being hunted once again using fair-chase principles. Fair-chase hunting of bison has not existed in many states, tribal landscapes or provinces for more than 150 years and is much more challenging to achieve because of the continuing human narratives and feelings about the historic destruction of bison and intact native grasslands. However, many conservationists contend that several intact large-scale grasslands still remain where bison may still roam as wildlife and that there is just enough time to restore the important ecological, social and cultural functions played by wild bison on some of these remaining grasslands. This notion of ecological restoration has become possible because of the successful first recovery that saved representation of the species in dozens of foundation herds.

Advancing this modern bison conservation vision of restoring full ecological restoration of American bison emerged out of several forward-thinking and complementary efforts by multiple conservation organizations. About two decades ago, two major Great Plains eco-regional assessments were conducted by the Nature Conservancy and World Wildlife Fund that identified important large grassland landscapes that warranted conservation in North America. As a result of these assessments, a large-scale prairie restoration initiative was started in north-central Montana in 2001 as the Prairie Foundation, which was initially an independent nonprofit organization, was later renamed the American Prairie Foundation and is now simply the American Prairie Reserve. Its mission is to establish a large prairie reserve that includes bison as a major ecological force to help shape and preserve this important landscape. The American Prairie Reserve began purchasing private lands from willing sellers in 2004 to serve to connect a vast mosaic of existing public lands so that the region can be managed collaboratively with state and federal agencies for wildlife and prairie conservation. To date, the American Prairie Reserve has completed more than twenty-five land transactions to build a habitat base approaching 400,000 acres, with a bison herd that now exceeds one thousand animals. Its vision is to protect the largest prairie grassland preserve in the world and host up to ten thousand bison on it. Since the mid-1980s, the Nature Conservancy has included bison as an important grazing tool for ecological management of thirteen grassland preserves. The Nature Conservancy Canada also manages a conservation herd of American bison on its Old Man on His Back natural area in Canada.

A new bison restoration vision was initiated by the Wildlife Conservation Society, formerly the New York Zoological Society, in 2005. Keith Aune (then with Montana Fish, Wildlife and Parks) and Jack Rhyan (with U.S. Department of Agriculture) approached the Wildlife Conservation Society to encourage it to reestablish the American Bison Society on its one-hundred-year anniversary. The Wildlife Conservation Society still owned that organizational title and hosted the original American Bison Society at the Bronx Zoo in 1905, so it was the logical organization to launch its rebirth. The Wildlife Conservation Society leadership, under the direction of Steve Sanderson, Kent Redford and Bill Weber, was strongly supportive of this idea and began the methodical process of developing both the scientific and social bases for ecological restoration under a newly established American Bison Society banner.

The first step in this project was to conduct a range-wide priority assessment for the species, which was completed in May 2006 during a landmark gathering at the Vermejo Park Ranch in New Mexico, according to the study "The Ecological Future of the North American Bison." At that same meeting, the basic tenets of ecological restoration were drafted, and from these, bison enthusiasts formulated the inspirational "Vermejo Vision," which clearly defines bison ecological restoration. In order to validate these products from the Vermejo meeting, a critical stakeholder workshop was convened in October 2006 to share the vision and inspire others to think about ecological restoration, as Redford and Fearn's 2007 work noted. Through these meetings, a new forward-thinking vision for the future of American bison was introduced into the North American conservation dialogue.

Parallel to the reestablishment of the American Bison Society, the American Bison Specialist Group, of the International Union for Conservation of Nature, was formed in 2005. Initially led by Dr. Cormack Gates from Canada, then Keith Aune from Montana and now Dr. Glenn Plumb, also from Montana, this international team of more than seventy experts in bison ecology, management, economics and social science from across North America completed a comprehensive status review in 2010 and provided technical guidelines for accomplishing bison restoration. This document provided a strong scientific assessment of the current status of conservation bison and presented best scientific tools and techniques for practicing restoration. The American Bison Specialist Group also published a comprehensive "Red List Assessment" in 2017 to evaluate an updated status of wild bison in North America. This body of bison experts provides a lasting resource of experts to help inform management of existing wild bison and restoration of new herds.

Since that benchmark year of 2005 and the articulation of the Vermejo Vision, several new state, provincial and federal government bison initiatives have also begun. In 2008, U.S. Secretary of the Interior Dirk Kempthorne issued a secretarial order establishing a formal Department of Interior Bison Working Group that includes representatives from all department agencies who meet to coordinate bison conservation and restoration efforts. In 2012, Secretary of the Interior Ken Salazar ordered this group to prepare a document outlining future bison restoration opportunities, and it published a departmental report entitled "Looking Forward" in June 2014 after lengthy discussions and substantial internal review. In this unique report, the department described ongoing commitments to bison conservation and

The newly established board of the American Bison Society reestablished in 2006 at Chico, Montana. *From left to right*: Kent Redford, Jodi Hilty, Curt Freese, Peter Dratch, Keith Aune and Dave Carter. *Wildlife Conservation Society.*

The IUCN Bison Specialist Group meeting in Banff, Alberta, during the Biennial American Bison Society Conference, 2016. *Photograph by Keith Aune.*

outlined future opportunities to cooperate with a broad array of partners to reintroduce bison to additional federal landscapes.

In 2015, the National Park Service released a "Call to Action" report to help shape the vision for the agency's next one hundred years. During the prior one hundred years, the National Park Service incrementally expanded several of its existing bison herds and begun planning to establish new bison herds. Since the time of Theodore Roosevelt, the National Park Service has been working hard to restore bison to as many national parks as feasible and better manage the premier herds that function as wild bison. In its latest "Call to Action," NPS identified continuing bison conservation as one of the priority activities it would continue during the next one hundred years.

Also, since 2005, several very exciting bison restoration efforts have been put forth by state wildlife agencies. In Utah, bison were reintroduced into the Book Cliffs area in 2009 through a cooperative effort by the Utah Division of Wildlife Resources, Bureau of Land Management and the Ute tribe. This reintroduced herd is already thriving, and a limited trophy hunt has been instituted. Alaska restored wood bison to the Lower Innoko region of central Alaska in 2014, creating the first wood bison restoration effort within the United States. This restoration was fraught with tremendous logistical and political challenges, but the Alaska Game and Fish Department prevailed through remarkable persistence and extensive planning. The first wood bison calves born in Alaska wildlands were reported in April 2015, and the population has grown to 150 animals. In 2015, the State of Montana announced a decision to allow bison access to more habitat near Yellowstone National Park. This represents the most significant expansion of the range of wild bison from Yellowstone National Park since their protection in 1872. Additionally, the Arizona Game and Fish Department has taken the lead for innovative bison conservation on state and U.S. Forest Service jurisdictions adjacent to Grand Canyon National Park. The agencies are hoping to shape seasonal migration of wild bison between summer and winter ranges so as to help sustain their long-term conservation.

Bison restoration is not just an adventure for those living within the United States. There are important and substantial efforts aimed at restoring wild bison in Canada and Mexico. Few people recognize that bison were once common in northern Mexico, but it is well known that the earliest European accounts of buffalo come from the Southwest, as Spanish colonizers explored the area in the sixteenth century. As recently as 2010, a small wild herd of bison wandered back and forth across the Mexico and New Mexico border in the area known as the Janos Biosphere Reserve. This herd, unfortunately,

Broken and rough country at Theodore Roosevelt National Park. *Photograph by Keith Aune.*

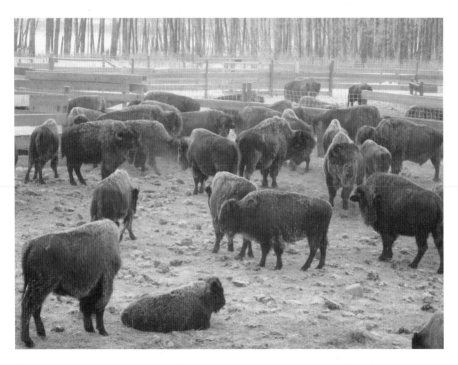

Wood bison hosted at the Alaskan Conservation Center before eventually being transported to a new home in central Alaska, 2008. *Photograph by Keith Aune.*

was reduced to a remnant when most were captured by a New Mexico rancher when they moved into the United States. These formerly wild bison were listed as endangered in Mexico and were highly valued by the people of Mexico. In response to that loss, the government of Mexico teamed up with the Nature Conservancy and started a new conservation herd on the El Uno Ecological Reserve, which is farther from the border. Here, a small group of twenty-three bison from Wind Cave National Park was introduced to the reserve, creating a herd that is managed on exceptional southern grassland in the province of Chihuahua. This bison restoration effort is well underway, and the herd now numbers over seventy animals, with hopes to expand their range. In Mexico, the Comisión Nacional de Áreas Naturales Protegidas has identified nine potential restoration areas in the provinces of Sonora and Chihuahua.

Canada has been a prominent champion for bison recovery since the late 1800s and has launched several important initiatives to conserve and restore both wood and plains bison. The provinces and federal government launched a wood bison recovery strategy in 2001 and recently released an updated wood bison conservation strategy in 2016 that is currently under external review. That recovery strategy resulted in the establishment of many new herds of wood bison on large landscapes so as to recover this once decimated subspecies of American bison. This has to be one of the largest and most successful modern efforts to restore bison and may lead to securing a great future for this subspecies in Canada. The picture is more tenuous for plains bison in Canada. There remain only a few areas, mostly within and near national parks, where plains bison are conserved. These parks are taking great strides in expanding their ranges or starting new herds of plains bison within existing jurisdictions. In 2014, Grasslands National Park purchased additional range and has the capacity to increase its herd to a sustainable level.

A reintroduction of plains bison into Banff National Park is underway, with a small pilot effort to bring bison to that region. On February 1, 2017, Parks Canada made history when it brought sixteen bison to the Panther Valley in Banff National Park. This was the first step in the five-year project to inform decisions regarding restoring wild bison in Banff over the long term. The herd is being held in an enclosed pasture in the Panther Valley so it can bond to its new home. This past spring, new calves were born, representing the first wild bison calves in Banff in more than one hundred years. In the spring of 2018, the bison were released to explore the full reintroduction zone in the remote eastern slopes of Banff. The source stock

for this restoration was from Elk Island National Park in northern Alberta. Elk Island National Park has served as a source for wood bison restoration in Alaska and delivered several shipments of plains bison to restoration projects on the American Prairie Reserve and Blackfoot Nation in Montana. Their homecoming in Banff is an ecological, historical and cultural triumph that coincides with the 150th anniversary of Canada's confederation. Finally, under the Canadian Species at Risk Act, the terrestrial mammal committee completed a full review on the status of wood and plains bison in Canada. The recommendations of the committee called for down-listing wood bison subspecies from threatened to a (sub)species of concern and up-listing plains bison to threatened status. A status decision, under the Canadian Species at Risk Act, on the overall status of overarching bison species is pending.

Since the first recovery of the American bison, many Indian tribes and First Nations have risen to the cause through several efforts to culturally restore bison to Indian country. Although some tribal efforts, like the Crow tribe's bison program, date back to the early 1960s, most tribal initiatives were put in motion after the formation of the Intertribal Bison Cooperative in 1992, now the Intertribal Buffalo Council, that was formed to begin returning bison to Indian country as a means of cultural enrichment as well as food production. The Buffalo Council has more than sixty member nations that have worked collaboratively to bring buffalo to tribal lands where they are managed as a culturally important resource, as well as a source of healthy food for Indian people. The council is formally chartered by the United States government and gives voice to the buffalo nations that once depended on this animal for food, clothing and inspiration. Many of the surplus animals from national parks and refuges are provided annually to the member tribes to support restoration of bison on Native American lands.

Beginning in May 2010, the Wildlife Conservation Society and members of the Blackfoot Confederacy (Kainai, Siksiika, Piikani and Amskapipikuni) held a series of transboundary dialogues that brought together elders and tribal members to create a grass-roots restoration vision for Blackfoot country. From these dialogues, the Iinnii Initiative was born. The Iinnii Initiative calls on the Blackfeet to develop a holistic and culturally appropriate vision for the conservation of lands on the Rocky Mountain Front to preserve Blackfoot culture and provide a homeland for bison. Restoring bison to this area will have several important benefits: 1) The rich wildlife assemblage and predator-prey systems—including elk, pronghorn, bison, wolves and grizzlies—would be complete; 2) Natural bison grazing patterns would

contribute to the integrity and resilience of the ecosystem; 3) The tribes of the Blackfoot Confederacy would have the opportunity to reconnect with a living symbol of their ancient culture; and 4) Bison, and the grasslands to support them, would provide the basis for nature-based businesses.

On April 4, 2016, eighty-seven calves from Elk Island National Park that are the direct genetic descendants of nineteenth-century bison from the Blackfeet Reservation, were transported to holding pens on the Buffalo Calf Winter Camp Ranch, along the Two Medicine River on the reservation. This is a mere thirty miles south of where it is reported that Samuel Walking Coyote captured wild bison calves in 1872 that eventually formed the Elk Island National Park bison population. This new herd will form the source stock for restoration efforts into larger landscapes along the Rocky Mountains once final land arrangements are completed. This project will result in a large-scale bison restoration project with tremendous ecological, economical and cultural benefits to the Blackfoot Nation.

The wild bison conservation story is complicated by the presence of many herds of privately owned bison for commercial meat production. Most privately owned herds in North America are managed primarily for meat production and may or may not give attention to the natural evolution

Elk Island bison calves loaded for the trip from Elk Island National Park to the Blackfeet Reservation, Montana, 2016. *Photograph by Jeff Morey, WCS.*

of the species as native wildlife. There are nearly 400,000 bison in private ownership, and management approaches for these herds are highly variable, from near feedlot situations to large-scale ranch herds. There is considerable debate over the role of commercial bison in the long-term conservation of the species, and many think it is inappropriate to characterize these ranched bison as a restored wild-type bison. The National Bison Association, which represents bison producers in the United State, has been developing conservation guidelines for producers to enable at least some bison managers to focus their management toward conservation of the species as well as commercial meat production. However, not all producers have interest in striving for conservation approaches, and there is no means of enforcing such standards. Another consideration for the inclusion of privately owned bison into the conservation huddle is that there is no assurance they would remain as a long-term component of those private lands. Individual ownership includes the right to change management or even eliminate their bison in order to accommodate some other use of the privately owned land. It remains to be seen if commercial bison producers can organize their goals and objectives to include long-term conservation of the species as wildlife.

The second recovery of the American bison is mounted squarely on the shoulders of previous great conservation champions such as Theodore Roosevelt, state and federal agencies, tribal nations and conservation organizations like the American Bison Society. The wide variety of modern initiatives is fundamentally possible only because of conservationists, Native Americans and ranchers who initially saved the last remnant herds of bison during the first recovery effort. However, when we cast our eyes forward, the American bison cannot be considered ecologically restored until some large blocks of native habitats contain more large bison herds that are genetically, behaviorally, ecologically and functionally similar to what previously existed on the Great Plains. This does not mean returning to the oceans of grass and 60 million bison or restricting personal rights to commercially ranch bison. It means that we have to complete several large-scale conservation projects over the next few decades on the remaining intact priority grasslands in the United States, Mexico and Canada in order to secure an enduring ecological future for American bison.

The question often posed is how this can happen, given the highly modified Great Plains and a limited amount of publicly owned lands. The answer is that to restore and conserve a large, wide-ranging mammal such as the American bison in our modern world, we will require new

models and novel approaches in conservation practice. The long-standing North American wildlife management model arose in the early part of the twentieth century, when the scale of conservation remained relatively small and the science of wildlife management had just developed. It was based on the notion of a harvestable surplus of game that should be managed to sustain an annual yield and conservation that was funded through sportsman fees and revenues for the privilege of hunting wildlife to harvest that yield. This was a functional model for its initial inception, as well as for another one hundred years. It successfully increased the number of game birds, waterfowl, deer, elk and antelope across North America. Although it served these favored game species very well and functioned for that time, it is now being tested by changing land management schemes; new ecological principles; the return of wide-ranging species like wolves, bears and bison; the ever-growing human footprint; and an increasingly urbanized society in America. The challenge before us, in the twenty-first

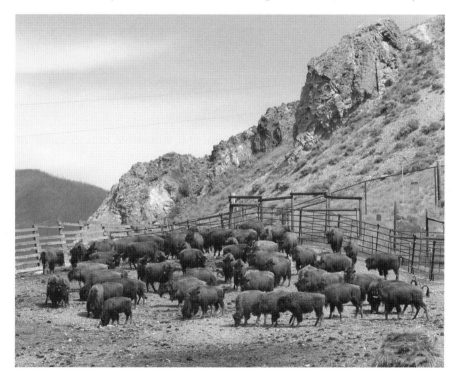

Yellowstone bison hosted at the quarantine facility near Corwin Springs, Montana. These animals were used to establish a satellite herd of Yellowstone animals at the Fort Peck Reservation in Montana. *Photograph by Keith Aune.*

century, is going to be how to adapt this one-hundred-year-old model to a new and different world—or perhaps even inventing new models that will better serve the next one hundred years.

The truth is that the North American wildlife model was, and is, actually many variations of the model that are erroneously rolled up into one in the minds of many modern wildlife managers. The varied and changing landownership patterns across North America today frequently contest the basic principles of this model and eventually will require quite modified versions and diverse management strategies for wildlife management under changing times. For example, the national parks in North America rapidly expanded in number during the twentieth century, and many national parks do not practice the annual hunting harvest of wildlife, although parks in Alaska are governed under specific laws and policies to allow subsistence harvest by native people. National parks do not receive fees specifically from hunters, rather revenue for management of these lands is primarily tax and visitor fee receipts from all citizens, hunters or not. Tribal lands, representing many sovereign nations, typically do not practice the North American wildlife model in its original design, as they develop their own wildlife conservation programs on millions of acres. Even the United States wildlife refuge system represents a hybrid system where some refuge lands are used for hunting harvest while others are fully protected from hunting.

Examination of the private sector shows a wide range of wildlife management strategies applied to vast tracts of privately owned wildlife habitat. In some cases, public hunting is a critical activity on private land, while other private landowners may lease hunting rights to an outfitter business, and others do not allow hunting at all. States like Texas routinely practice an entirely different management model using a private hunting reserve approach, where revenue is generated for the private individual who practically owns the wildlife on his land or may even introduce exotic wildlife onto private property for the purpose of private hunting. Thus, a careful review of the various geographies in North America reveals that the North American wildlife model in its fullest form may represent less than half of the continent, while other wildlife management models are exercised across many areas of North America.

A new ecology-based conservation movement has recently arose and is aimed at preserving wide-ranging wildlife, protecting long-distance wildlife migrations and practicing conservation at larger scales. As we look forward, the prevailing science argues for larger landscape conservation initiatives and new ideas of sharing stewardship of wildlife resources across multiple

jurisdictions. To do this, we must adapt currently outdated management strategies and create some collaborative approaches that enable wide-ranging species, like bison, to live and thrive on large landscapes. This ecological vision of large-scale conservation could fundamentally transform wildlife management in North America, and the American bison is again a catalyst for transformation.

The conservation of American bison is once again fundamentally challenging the dominant conservation paradigm in the United States because bison require large landscapes, compete with livestock and must exercise extensive mobility to ecologically function in grassland ecosystems. To date, conservation has enthusiastically demonstrated the ability to preserve these animals in a fenced model and strictly managed landscapes at medium to small size (1,000–70,000 acres). Yet larger-scale initiatives (100,000–1 million acres), where bison are able to move freely across the landscape, interacting with other wildlife and the plant community, are few and far between. As of 2016, there were only twenty-one free-ranging bison herds, representing about eighteen thousand animals, found across North America. Only eight of these herds, representing a total of fifteen thousand bison, are of found on large-scale landscapes (millions of acres),

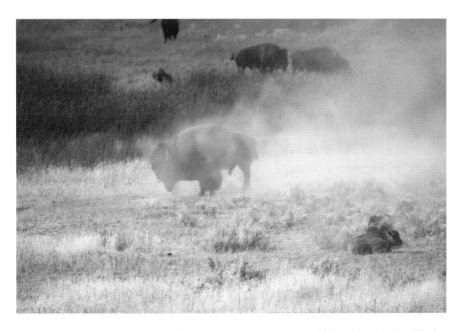

A bull bison raising dust from a wallow during the annual rut in Yellowstone National Park. *Photograph by Keith Aune.*

where the forces of natural selection, like large carnivore predation, operate and bison move freely across the entire range. Our current portfolio of bison conservation herds is woefully inadequate to ensure the evolutionary future of the species, yet bison are not at yet a critical risk for extinction.

The future continued evolution of a wild-type bison is dependent on the restoration of more large herds on larger landscapes, where the full suite of natural behaviors can be expressed. Confinement and increasing domestication of American bison prominent in many herds may have negative long-term consequences to behavior and activity patterns. Unnatural selection, for a constrained suite of behavior traits, could result in a maladapted bison not fitted to the natural environment. Bison may be at risk for ecological extinction, where their primary function is no longer expressed in nature and they cannot be managed without major human interventions that further introduce an artificial selection pressure. This would be a significant alteration in the natural evolutionary path of this noble creature and a tragic fate for a species that has a keystone role in grassland ecosystems.

To achieve ecological restoration with full functionality for this species, the conservation community is faced with serious challenges regarding where, when and how we practice large-scale conservation on grasslands and prairies. Modern bison managers are faced with the limitations of the old North American Model, questions of genetic integrity and an urgent need to invent new business and operational practices to sustain large herds of wild bison. These notions of creating innovative models for large-scale conservation practice is slowly emerging but may require several decades to fully mature.

Although the idea has been expressed often among conservationists for decades, we desperately need functioning and working pilot projects "on the ground" to quickly gain experience under this new vision. This idea was discussed at the American Bison Society Conference in Big Sky, Montana, in 2013 and was given the term "Shared Stewardship." At Big Sky, biologists and managers defined key principles for achieving ecological restoration for bison at large scale and for long term. This approach of shared-stewarding bison populations will require new relationships, legal instruments and partnerships to share the responsibilities as well as economic and cultural benefits. Public, tribal and private interests, as well as potential conflicts, must be negotiated while ensuring that ecological principles and conservation practices are not compromised.

A new problem facing the ecological restoration of bison is the preservation of the genetic capacity for species to evolve given the severe

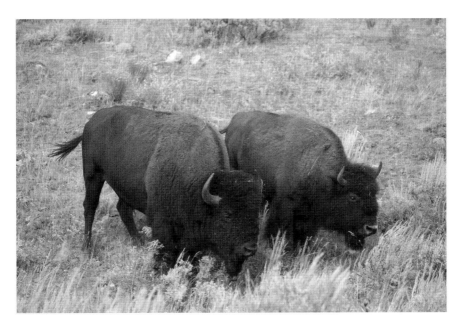

A bull bison tending a female during the annual rut in Yellowstone National Park. *Photograph by Keith Aune.*

genetic bottleneck that arose in the nineteenth century. Managing for genetic integrity, which has been damaged by the great destruction of bison, and historic management decisions made during the first recovery of American bison are not insurmountable. Two major issues for preserving the bison genome are addressing cattle gene introgression and hybridization of the two recognized subspecies, wood and plains bison.

Cattle genes were introduced into many plains bison in the late nineteenth and early twentieth centuries as a result of hybridization experiments with cattle. We have technical tools to limit or reduce the amount of cattle gene in bison herds and management tools to protect bison herds without cattle genes. A recent project forged through a collaboration between the Wildlife Conservation Society and the U.S. Department of the Interior is looking across all federal herds (and a few Canadian herds) to determine the genetic status and long-term viability of these bison herds and to work collaboratively toward a science-based meta-population strategy for continental conservation to ensure long-term genetic conservation. Science is gradually proceeding on several fronts among agencies, nongovernment organizations, tribes and academics to better address cattle gene introgression and promote genetic diversity for the American bison. New genetic testing protocols and a map of

the bison genome can help inform future decisions about bison husbandry and management. However, we must proceed with caution when using these new tools to manage herd genetics so we do not sacrifice current levels of diversity in a quest for purity.

Wood and plains bison were extensively hybridized after plains bison were translocated into wood bison range near Wood Bison National Park in Canada in the 1920s. Today, we suffer the consequences of those actions, and it is unlikely that we can ever fully correct this problem. Although the taxonomic status of the two bison "subspecies" has been vigorously debated, it may not be a very important issue for building an enduring conservation strategy for American bison. To advance bison conservation, the scientific community has agreed that it is reasonable and appropriate to recognize the two distinct population segments, routinely referred to as plains and wood bison, irrespective of the ongoing taxonomic debate of sub-specific designation. Old and new evidence suggests that there is a valid genetic distinctiveness between these designable units, including inherited traits (behavioral and morphological) and genetic markers. In addition, a natural distinction has been historically acknowledged between the original ranges of wood bison and plains bison.

The final bit of evidence for discreteness is that wood bison and plains bison originally occupied different habitats, with different environmental conditions, to which each were uniquely adapted. After a lengthy discussion about this at several recent American Bison Society workshops and conferences, it was agreed that we are better served to focus management on exposing the bison genome to natural selection that put bison back on the proper evolutionary pathway. Nature can best sort out the previous management mistakes and provide us with wild bison of the future, if we will allow it. But that means establishing large-scale projects where selection can operate. The bottom line is that we have the bison we inherited and must move forward in our management to ensure that bison function both ecologically and evolutionarily and to maintain the wild nature of bison for the long term.

Another modern challenge to recovery of wild bison is not biological, but rather the persistent confusion about the status of wild bison and overcoming a common public perception that bison no longer belong on intact grassland landscapes except behind a fence. Are bison livestock or are they wildlife? As a result of the historic management model applied to bison, often a version of agriculture, many people believe that bison should only be managed as livestock and should not be allowed to roam widely beyond fenced habitats. It is unfortunate that in the United States, we have persisted in thinking of bison as an ancient relic, or livestock, to be viewed behind a fence but

never fully experienced like other wildlife. The future for bison is dismal if these views remain entrenched in the American psyche. The key to the ecological recovery of this species is recognition that the American bison is a wildlife species that needs to be managed as wildlife. Many conservationists consider it socially and biologically unacceptable that the extirpation of the bison as a wildlife species on the Great Plains should persist to this day. Except for bison, North America has done an outstanding job of restoring other wildlife species that were decimated during the nineteenth and early twentieth centuries, including many bird species, elk, mule deer, white-tailed deer, antelope, bears, wolves, bighorn sheep and mountain goats. We should be proud of this wonderful heritage, but we also must remain vigilant to extend that success to all wildlife, including the American bison.

In a new approach to large-scale bison restoration, innovative business models will be necessary to address revenue streams, define customers and share operating expenses when managing a wide-ranging species like bison. These new business models will need to blend for-profit and nonprofit elements to support venture costs. They must incentivize the partners and support human livelihoods on these large landscapes. Revenue streams beyond the typical hunter license fees will be necessary, and expenses for living with a large wide-ranging mammal could be significant. There will be many trade-off decisions and complicated economic transactions between the various interests. These challenges put our restoration adventure in uncharted territory and make it inherently more complex. Although the risks may be great, rewards could transform conservation and create an entirely new legacy of conservation practice.

Our optimism for a new vision of "shared stewardship," for bison ranging across large landscapes, is based on our own interpretation of history, as well as the example that Theodore Roosevelt, and his progressive reformers provided during another time of great transformation. We find that in their place and time, conserving nature and saving wild bison were not widely accepted, and few could believe that bison restoration could possibly render economic benefits to mankind. Most people living in the nineteenth century also could not perceive that a beneficent government could be empowered by the people to serve a cause like wildlife conservation. Yet the conservation champions of that day fearlessly imagined new possibilities, met challenges with ingenuity and developed an entire conservation culture that moved society toward their cause. The conservation champions imagined a new way for Americans to maintain a relationship with nature and remain a prosperous nation. We can do no less in our time of change and challenge.

PRINCIPLES FOR ECOLOGICAL RESTORATION

The American bison tale is still being written today, and it remains to be seen how we compose that next chapter in this great story. We have only just begun to reimagine the North American prairies and woodlands, painted with bison managed cooperatively under shared stewardship—with large herds grazing, wallowing, nourishing people and predators, sustaining the belief that we can work toward this large-scale, ambitious and long-term vision. Bison ecologists are establishing a new framework to achieve ecological restoration at scale that embraces six important guiding principles.

PRINCIPLE 1. THINK AND ACT LONG TERM. A fundamental concept that applies to the practice of conserving and restoring bison is to think long term. This brings us back to the ancient and wise Iroquois notion of Seven Generations Thinking. Every decision we make today has implications for approximately the next 100 years (assuming a human generation of 34 years). Today, we are at a significant crossroads in the quest to ecologically restore the American bison. Although we have enjoyed great successes over the last 110 years since the bison conservation efforts were first attempted, we have not ensured the genetic and evolutionary future of bison. Today, we have only eight conservation herds that are fully functional bison in a free-ranging condition. Two of these herds, at Yellowstone and Wood Buffalo National Parks, demonstrate significant demographic and genetic resilience. However, the best available science shows us that other than Yellowstone and Wood Bison National Parks, the ecologically functional bison herds will lose between up to 8 percent of their genetic diversity over the next seven human generations. This finding is not very surprising, or terribly alarming, but it implies that we just have the time to adjust our management to minimize this loss of diversity by the progressive actions we can take today. Aside from these eight wild bison herds that function ecologically, all the remaining conservation bison, tribal bison and commercial bison herds can be expected to lose even greater diversity without constant human interventions. This prediction, and predicament, argues that we need to determine how best to intervene now and prevent a future genetic catastrophe for this species.

PRINCIPLE 2. THINK AND ACT TOGETHER. Just as Theodore Roosevelt convened the progressive thinkers of his time to create a vison for bison recovery, modern bison conservationists have convened to consider the second bison recovery and craft an inspiring vision, while putting modern

champions to work implementing it. In 2006, the Vermejo Vision statement was developed after convening some of the best conservationists from the bison world. This vision espouses that ecological restoration of the American bison will occur when multiple large herds of plains and wood bison move freely across extensive landscapes within all major habitats of their historic ranges, interacting in ecologically significant ways, with the fullest possible set of other native species, and inspiring, sustaining and connecting human cultures. This will be realized through a collaborative process engaging a broad range of public, private and indigenous partners who share in the stewardship of American bison by:

- maintaining herds that meet the criteria for ecological restoration, as well as herds that contribute in some significant way to the overall vision, regardless of size.
- managing herds so they are subject to natural selection and with attention to maintaining the health, genetic diversity and integrity of the species.
- restoring native ecosystems, ecological interactions and species.
- providing conservation and economic incentives for bison producers, managers and other stakeholders.

The international team formed to move eighty-seven Elk Island Bison from Alberta, Canada, to the Blackfoot Nation land in Montana in April 2016. *From left to right*: Joel Parrott, Fred Bull Calf, Ervin Carlson, Keith Aune, Stephen Fleming and Harry Barnes. *Photograph by Stephen Fairchild, WCS.*

- creating education, awareness and outreach programs to public and policy-making constituencies.
- conducting research and monitoring that lead to improved bison restoration and management.
- building capacity and sharing information among key stakeholder groups.
- working across international borders and other jurisdictional boundaries.

PRINCIPLE 3. SEEK TO RESTORE ECOLOGICAL FUNCTIONALITY. The major change between the first and second efforts to save American bison is the introduction of the concept of restoring ecological functionality, not just representation to the landscape. To enable that functionality in bison, we must protect natural patterns on the land and ecological processes operating within the system. These patterns consist of complex vegetation structure and composition, influenced by wide-ranging bison, that select and deselect specific grazing plants and habitats. These patterns preserve the functional relationships between plant and grazer essential to the evolution of grassland ecosystems. In addition, ecological functionality includes preserving animal-to-animal relationships found in communities within these ecosystems. Some

A bison bull preparing to wallow in Yellowstone National Park. Wallowing is a natural and beneficial impact to bison habitat. *Photograph by Keith Aune.*

of the connections we know are important include the influence of bison on grassland birds, burrowing mammals and various insects. These complex community relationships go beyond just the influence of grazing on plants and include intricate connections between bison and their environments through nutrient cycling (bison feces and urine deposition, as well as carcass decomposition), seasonal biological events (like hair shedding and calving), geomorphological influences (from horning, wallowing and trampling) and impacts on hydrology (the collection of temporary water in wallows and use of riparian areas). These are very important ecological relationships that have coevolved for tens of thousands of years and, until recently, were not fully understood. These relationships are not simply replaced by the introduction of another large grazer such as cattle, and their loss to the system affects ecosystem resilience and health.

PRINCIPLE 4. THINK AND ACT LARGE SCALE. Bison managers need to focus on large-scale conservation and novel opportunities for applying shared stewardship models. This new direction requires us to find the last remaining places where large landscapes conservation can occur among rapidly diminishing temperate grasslands of North America. To work at the large landscape scale, we need to join multiple jurisdictions into agreements that share the responsibility, and accountability, for preserving the American bison. The models emerging will knit the large landowners and managers in a specific geography with national parks, refuges, national forests and grasslands; tribal lands; and even private landowners willing to cooperate, and benefit from, mutual support to a common vision for the return of wild bison.

PRINCIPLE 5. THINK AND ACT THROUGH PLURALISM. Because this new vision will focus on sharing the stewardship of the bison resource, it will also require inspired human cultures that currently depend on and live on and near these lands. We will need the social license from affected citizens, that must be acquired by inclusion, inspiration, education and participation, to advance the second recovery of the American bison. The recent designation of bison as the United States National Mammal is an example of how we can inspire citizens across to think about the national significance and future of this animal. Annual public outreach on National Bison Day will help us grow the support for bison restoration and inspire people to that cause through storytelling, cultural activities and science education. We need new business models for inclusive economic partnerships among the private,

tribal and government interests and unique economic incentives to support humans whose livelihoods depend on these large grasslands. The people who would be most affected by the restoration of bison must be incorporated as stewardship partners, sharing in the benefits and responsibilities of bison conservation.

PRINCIPLE 6. THINK AND ACT WITH HOPE. Just as it was during the life and times of Theodore Roosevelt, and the conservation champions he recruited, preserving large landscapes that include wild bison may be an even more challenging battleground and requires a warrior mentality. Many people groups and governing bodies have competing interest in how these lands are used and who will benefit from them. It remains a significant challenge for those working to save bison today to guard the remarkable progress achieved by those who preceded us and to preserve options for the next generations. We must actively engage in land use decision processes and practice human conflict resolution to ensure a future for this species.

Senator John Hoeven of North Dakota (*third from right*), one of several champions who introduced the Bison Legacy Act naming bison our national mammal. Others present include, *from left to right*, John Calvelli, Keith Aune, Jim Stone, Dave Carter and Kelly Aylward. *Wildlife Conservation Society.*

Restoring the American bison has become a message of hope, inspiring action by many groups, from schoolchildren to tribal elders, academics and even some politicians. In this past decade, people have seized the initiative and acted with purpose to restore bison as wildlife from northern Mexico to the far north in Alaska, with individual projects erupting all across North America. Some of these new restoration initiatives have grown from significant cultural and social reasons, while other bison restoration initiatives are based on restoring ecological integrity on public lands for all people to enjoy. In this past decade, our expanding awareness and better understanding of the important history, ecology, economy and cultural spirit of bison, has promoted efforts to more fully embrace the largest land mammal in North America.

This symbolic importance of bison was federally recognized in May 2016 when President Obama signed the Bison Legacy Act designating bison as the United States National Mammal. At a time when there was much contention in Congress, the Bison Legacy Act passed unanimously in both the House and the Senate. The notion that bison deserve national recognition dates back to the original appeal for buffalo restoration, articulated by the American Bison Society in 1905. Finally, more than one hundred years later, this has finally been accomplished, and each year, a National Bison Day celebrates the species. There clearly is a rising modern-day call to revitalize our connections to wild bison landscapes and nurture the significant cultural ties to this magnificent animal. Several decades ago, Adolph Murie admonished conservationists with these words: "Let us not have puny thoughts. Let us think on a greater scale. Let us not have those of the future decry our smallness of concept and lack of foresight." We have begun to respond with a new and bigger vision for the ecological restoration of American bison, and what once seemed hopeless now seems possible.

THE LAST STAND?

For the past one hundred years, we have often read or heard the phrase "the last bison" or "the last stand" in book titles, popular magazine articles, news print, narratives about legacy bison, reports of remnant bison herds, dramatic hunting stories and historical descriptions of the destruction of bison. Although this terminology has frequently produced emotional and inspirational effects, it does not actually reflect the reality of bison restoration during the last one hundred years. In fact, history and contemporary adventures in bison conservation clearly argue against the notion that any one individual, any one restoration project or any one event represents the final stand for the American bison. When we examine the record carefully across the North American continent, we cannot single out that "last bison" or a "last stand" for bison because many recovery actions and restoration events were happening across the entire continent over the past one hundred years. To be more honest, bison recovery was actually accomplished by multiple early efforts involving different management models practiced at many locations across historic bison range and was led by many individuals, or people groups, over a considerable time span.

Although no single person can be given credit for saving American bison, some individuals do merit considerable attention as the conservation champions for this iconic species. In this book, we have profiled Theodore Roosevelt, who was the energetic champion who arrived at the right time in history with the right personal skills to promote a new conservation ideal and bring about first recovery of bison before it was too late. His gift was

not in doing the specific work afield but in organizing enthusiastic advocates, supporting skilled workers who did the hard work on the ground and inspiring many people, eventually the entire nation, to participate in this difficult but noble cause despite significant political resistance and negativity. His legacy was fashioning the legislative framework, the policy imperatives and the administrative processes that enabled his vision of conservation to persist even yet today. The need for conservation champions and bison advocates like Roosevelt and his colleagues remains with us today as we continue working toward the full recovery of the species. However, we are reminded that it took more than one of him, and it will take all of us, working together to achieve a second recovery for American bison.

American bison remain viable and persist today because of multiple human endeavors, changing human philosophies, proven resilience and, perhaps, a lot of good luck. They survive among us on dozens of landscapes and persist in our human consciousness through song (present and past), cultural practice, ancient and modern art, statuaries and multiple stories. Although our past relationship with them has been uncertain, volatile and even quite troubled, their persistence and resilience have proven more powerful than our human weaknesses. The American bison has faced the

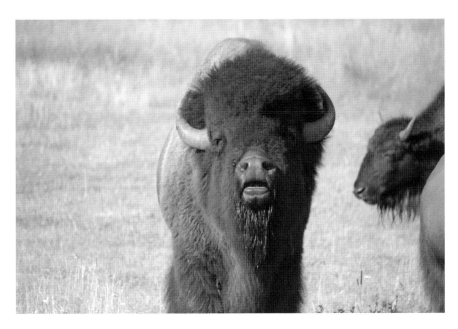

A large bison bull bellowing loudly during the annual rut. *Photograph by Keith Aune.*

storm and survived historical abuses, wholesale slaughter and degraded habitats for more than two hundred years but yet remain a living testimony to their powerful nature. Although their near destruction was certainly by the hand of humans, we also played a necessary role in bringing them back from the brink of extinction. Perhaps we are finally rediscovering and recognizing some of the important lessons demonstrated by this mighty animal for millennia.

The full recovery of bison is not just important for their future survival, but it may also be a moral imperative for humans to atone for the historical insults we delivered to this animal. We not only have a stewardship responsibility to restore bison in its physical form but also a moral obligation to return it as a force of nature, shaping healthy prairie landscapes, and a source of cultural inspiration for all people. We have already stepped on that difficult path toward achieving cultural, ecological and historical recovery for the American bison, and now we must persist in our travels. There is no turning back. We need to look forward and ultimately achieve what we refer to as the "second recovery" of American bison. By choosing this path, we honor the vision of Black Elk and ensure that future generations will have opportunities to walk into the clear wind, hear a wild bison's bellow on the Great Plains once again and experience healthy, intact grassland communities that are shaped by this influential keystone herbivore.

BIBLIOGRAPHY

Ambrose, Stephen. *Nothing Like It in the World: The Men Who Built the Transcontinental Railroad, 1863–69*. New York: Simon & Schuster, 2000.

American Prairie Reserve. https://www.americanprairie.org/our-story.

Audobon, John James. *Audubon's Wildlife: The Quadrupeds of North America*. Stamford, CT: Longmeadow Press, 1989.

Ballantine, Betty, and Ian Ballantine. *The Native Americans: An Illustrated History*. East Bridgewater, MA: World Publication Group, 2011.

Bechtel, Stefan. *Mr. Hornaday's War: How a Peculiar Victorian Zookeeper Waged a Lonely Crusade for Wildlife that Changed the World*. Boston: Beacon Press, 2012.

The Boone and Crockett Club: A History (1897–2013). Missoula, MT: Boone and Crockett Club, 2013.

Brinkley, Douglas. *The Wilderness Warrior: Theodore Roosevelt and the Crusade for America*. New York: HarperCollins Publishers, 2009.

Brooks, Chester, and Ray Mattison. *Theodore Roosevelt and the Dakota Badlands*. Washington, D.C.: National Park Service, 1958. Reprint, Medora, ND: Theodore Roosevelt Nature and History Association, 1983.

Brower, Kenneth. *American Legacy: Our National Forests*. Washington, D.C.: National Geographic Society, 1997.

Burroughs, Raymond D. *The Natural History of the Lewis and Clark Expedition*. East Lansing: Michigan State University Press, 1961.

Callenbach, Ernest. *Bring Back the Buffalo: A Sustainable Future for America's Great Plains*. Berkeley: University of California Press, 2007.

Danz, Harold P. *Of Bison and Man*. Niwot: University Press of Colorado, 1997.

Dary, David A. *The Buffalo Book: The Full Saga of the American Animal*. Athens, OH: Swallow Press, 1989.

Day, Donald. *The Hunting and Exploring Adventures of Theodore Roosevelt: Told in His Own Words*. New York: Dial Press, 1955.

Dormaar, J.F., and R.L. Barsh. *The Prairie Landscape: Perceptions of Reality*. Alberta Prairie Conservation Forum. www.albertapcf.org/rsu_docs/occasional_paper_3.pdf.

Egan, Timothy. *The Big Burn: Teddy Roosevelt and the Fire that Saved America*. New York: Mariner Books/Houghton Mifflin Harcourt, 2010.

Emerson, Ralph W. *Nature: Addresses and Lectures*. Philadelphia: David McKay Publisher, 1894.

Gates, C.C., C.H. Freese, P.J.P. Gogan and M. Kotzman, eds. and comps. *American Bison: Status Survey and Conservation Guidelines 2010*. Gland, Switzerland: IUCN, 2010.

Geist, Valerius. *Buffalo Nation: History and Legend of the North American Bison*. Stillwater, MN: Voyageur Press, 1996.

Haynes, Aubrey. *The Yellowstone Story: Volumes One and Two*. Yellowstone National Park, WY: Yellowstone Library and Museum Association, 1977.

Hornaday, William. *The Extermination of the American Bison*. Washington, D.C.: Smithsonian Institution Press, 2002.

Isenberg, Andrew C. *The Destruction of Bison*. New York: Cambridge University Press, 2000.

Jeffers, H. Paul. *Roosevelt the Explorer: Teddy Roosevelt's Amazing Adventures as a Naturalist, Conservationist and Explorer*. Lanham, MD: Taylor Trade Publishing, 2003.

Johnston, William Davison. *TR: Champion of the Strenuous Life—A Photographic Biography of Theodore Roosevelt*. Oyster Bay, NY: Theodore Roosevelt Association, 1958.

King, T. *The Truth About Stories: A Native Narrative*. Minneapolis: University of Minnesota Press, 2005.

Lepley, John G., and Sue Lepley. *The Vanishing West: Hornaday's Buffalo*. Big Sandy, MT: Rettig Publishing Inc./Mountaineer Printing, n.d.

Library of Congress. "Evolution of the Conservation Movement." American Memory Project. http://memory.loc.gov/ammem/amrvhtml/conshome.html.

Locke, Harvey. *The Last of the Buffalo: Return to the Wild*. Banff, AB: Summerthought Publishing, 2016.

McCullough, David. *Mornings on Horseback*. New York: Simon & Schuster, 2001.

McHugh, Tom. *The Time of the Buffalo*. Lincoln: University of Nebraska Press, 1979.

Miller, Nathan. *Theodore Roosevelt: A Life*. New York: William Morrow and Company, 1992.

Mooallem, Jon. "How the Greatest Taxidermist Helped Save the Buffalo from Extinction." *Slate*, May 7, 2013. https://slate.com/articles/arts/culturebox/2013/05/william_temple_hornaday_how_a_taxidermist_helped_save_the_buffalo.

Neihardt, John G. *Black Elk Speaks: Being the Life Story of a Holy Man of the Oglalla Sioux*. Lincoln: University of Nebraska Press, 1961.

Picton, Harold. *Buffalo: Natural History and Conservation*. Stillwater, MN: Voyageur Press, 2005.

Plumb, G.E., P.J. White and K. Aune. "American Bison *(Bison bison)* (Linnaeus, 1758)." In *Wild Cattle of the World*. Edited by M. Melletti. Cambridge, UK: Cambridge University Press.

Posewitz, Jim. *Rifle in Hand: How Wild America Was Saved*. Helena, MT: Riverbend Publishing, 2004.

————. *Taking a Bullet for Conservation: The Bull Moose Party—A Centennial Reflection, 1912–2012*. Helena, MT: Riverbend Publishing, 2011.

Redford, Kent, Keith Aune and Glenn Plumb. "Hope Is a Bison." *Conservation Biology* 30 (2016): 689–91. doi:10.1111/cobi.12717.

Redford, K.H., and E. Fearn. *The Ecological Future of the North American Bison*. Bronx, NY: Wildlife Conservation Society, 2007.

Renehan, Edward J. *John Burroughs: An American Naturalist*. Hensonville, NY: Black Dome Press, 1998.

Report of the American Bison Society. New York: American Bison Society, 1908. Courtesy of the Wildlife Conservation Society Library and Archives.

Roosevelt, Theodore. *Hunting Trips of a Ranchman and Wilderness Hunter*. New York: Modern Library Paperback Edition, 2004.

————. *Theodore Roosevelt, an Autobiography*. Reprint, Boston: De Capa Publishing, 1985.

Roosevelt, Theodore, and George Bird Grinnell, eds. *American Big Game Hunting*. Missoula, MT: Boone and Crockett Club, reprinted 2011.

Sanderson, E.W., K. Redford, B. Weber, K. Aune, D. Baldes, J. Berger, D. Carter, C. Curtin, J.N. Deer, S. Dobrott et al. "The Ecological Future of the North American Bison: Conceiving Long-Term, Large-Scale Conservation of Wildlife." *Conservation Biology* 22 (2008): 252–66.

Shell, Hanna R. "The Last of the Wild Buffalo." *Smithsonian Magazine* (2000). https://www.smithsonianmagazine.com/issues/2000/february/ object. feb00.htm.

Smits, David D. "The Frontier Army and the Destruction of the Buffalo, 1865–1883." *Western Historical Quarterly* 25, no. 3 (Autumn 1994).

Spry, Irene. *The Palliser Expedition: The Dramatic Story of Western Canadian Exploration, 1857–1860*. Boston: Fifth House Publishers, 1995.

Thoreau, Henry David. *Walden and Civil Disobedience*. New York: Barnes and Noble Books, 2003.

Trefethen, James B. *An American Crusade for Wildlife*. Alexandria, VA: Boone and Crockett Club, 1975.

Wallace, Anthony J.C. *Jefferson and the Indians: The Tragic Fate of the First Americans*. Cambridge, MA: Belknap Press of Harvard University Press, 1999.

Whealdon, Bon I. *I Will Be Meat for My Salish*. Pablo, MT: Salish Kootenai College Press, 2001.

INDEX